LOWCOUNTRY
from Charleston to Savannah

Photography by Bob Krist

Essay by Cecily McMillan

GRAPHIC ARTS CENTER PUBLISHING®

☙

To Tom and to Priscilla —C. M.

For Peggy —B. K.

☙

I'd like to thank the following people and organizations for their help in photographing this book. Amy Ballenger Guest of the Charleston Area CVB and Jenny Stacy, formerly of the Savannah Visitors Bureau, are longtime supporters with whom I've collaborated on many assignments. They were instrumental in allowing me the time and support to complete a project like this. I'd also like to thank Bill Struhs, a great photographer and friend, for his advice and counsel.

I extend a warm thank you to the Historic Charleston Foundation, Philip Simmons, Boone Hall, Magnolia Plantation & Gardens, Middleton Place, Cypress Gardens, and Drayton Hall, as well as Matt Owen of Kiawah Island, Jim Ellison of Flying High Over Charleston, the Ashley Hall School, and The Citadel. Tami and Frank McCann showed me some wonderful Charleston hospitality for which I am grateful.

Other people and organizations to whom I owe a debt of thanks are Bernie Wright of the Penn Center, Jim Wescott of the Lowcountry Regional Tourism, Cheri Had, of the U.S. Marine Corps Public Relations Department at Parris Island, Charles Gay, and Lowcountry Rafting Adventures. My thanks also to Adrianne King Comer, Sara Nesbit of Nia Productions, Roxane Luke, and Capt. Ron Elliott.

Others who graciously assisted were John and Virginia Duncan, John Berendt, Craig Stevens of SCAD, Erica Backus of the SVB, the Gastonian Inn, the Azalea Inn, and Laura and Don Devendorf of Melon Bluff, as well as the Telfair Museum of Art, Rabbi Arnold Mark Belzer of Temple Mickve Israel, the Cathedral of St. John the Baptist, John Stevens, Florence Roberts, and Seabrook Village.

My appreciation goes out to Doug Pfeiffer and Tim Frew of Graphic Arts Center Publishing® for commissioning this book and to Elizabeth Watson for her beautiful design. Finally, I'd like to thank the photo editors who first dispatched me to the Lowcountry, Bill Black, then of *Travel/Holiday* magazine, Albert Chiang of *Islands* magazine, and Hilary Genin of *Insight Guides*.

—B. K.

☙

All photographs © MMIV by Bob Krist
Photo notes and captions © MMIV by Cecily McMillan
Essay © MMIV by Cecily McMillan

All rights reserved. No part of this book may be reproduced or transmitted in any form or by any means, electronic or mechanical, including photocopying, recording, or by any information storage and retrieval system, without written permission of the publisher.

Library of Congress Cataloging-in-Publication Data

Krist, Bob.
 Lowcountry : from Charleston to Savannah / photography by
 Bob Krist ; essay by Cecily McMillan.
 p. cm.
 ISBN 1-55868-796-3 — ISBN 1-55868-840-4 (pbk.)
 1. South Carolina—Pictorial works. 2. Georgia—Pictorial works.
 3. South Carolina—Description and travel. 4. Georgia—
 Description and travel. 5. Landscape—South Carolina—
 Pictorial works. 6. Landscape—Georgia—Pictorial works.
 7. Islands—South Carolina—Pictorial works. 8. Islands—
 Georgia—Pictorial works. I. McMillan, Cecily, 1956– II. Title.
 F270.K75 2004
 975.7'044'0222—dc22
 2004001043

Graphic Arts Center Publishing®
An imprint of Graphic Arts Center Publishing Company
P.O. Box 10306
Portland, Oregon 97296-0306
503/226-2402
www.gacpc.com

Graphic Arts Center Publishing Company
President: Charles M. Hopkins
Associate Publisher: Douglas A. Pfeiffer
Editorial Staff: Timothy W. Frew, Tricia Brown, Kathy Howard,
 Jean Andrews, Jean Bond-Slaughter
Production Staff: Richard L. Owsiany, Heather Doornink
Designer: Elizabeth Watson
Map production/design: David Toney,
 Flat Planet Maps, www.flatplanetmaps.com

Captions: Page 1: An early explorer, so taken by the Lowcountry's beauty and climate, its abundance of flowering plants, birds, and fish, that he wrote he had found "no fayrer or fytter place."

Pages 4-5: Charleston is that rare American city that knows itself, is both passionate and detached, committed to honoring its three-century history yet, more than once, a victim of its pride.

Printed in Hong Kong

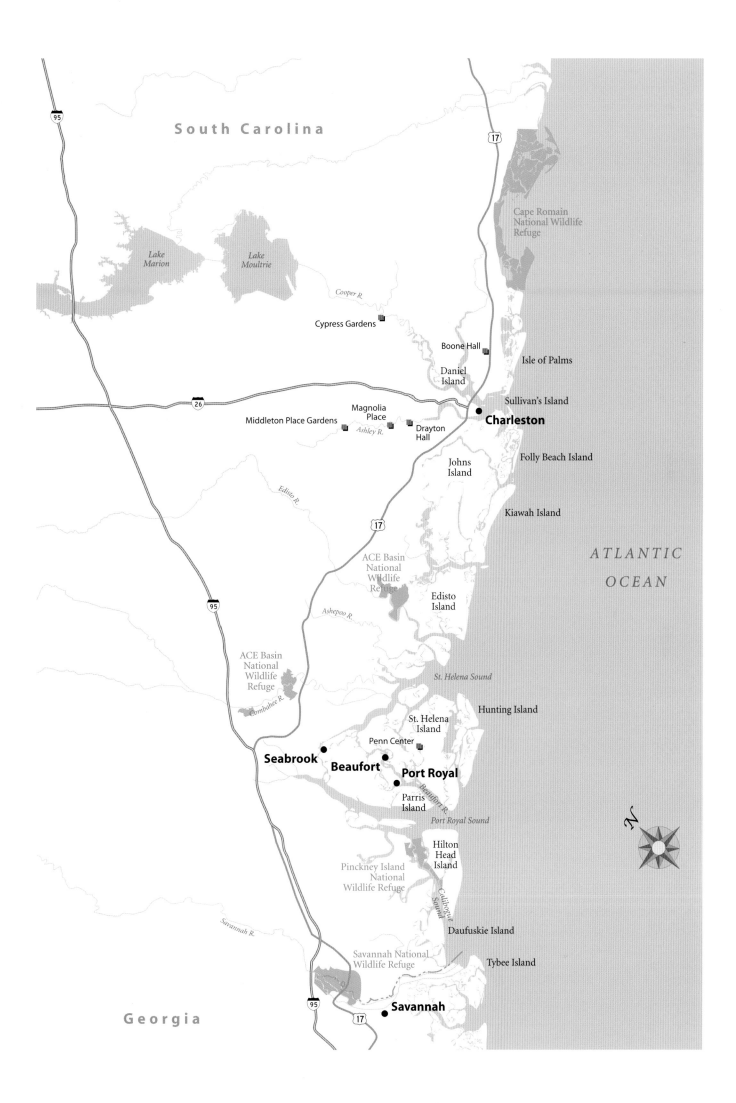

South Carolina

95

Lake
Marion

Lake
Moultrie

Cooper R.

Cypress Gardens

17

Boone Hall

Isle of Palms

Daniel
Island

Sullivan's Island

26

Magnolia
Place

Middleton Place Gardens

Charleston

Drayton
Hall

Ashley R.

Johns
Island

Folly Beach Island

Edisto R.

Kiawah Island

17

ATLANTIC
OCEAN

ACE Basin
National
Wildlife
Refuge

95

Ashepoo R.

Edisto
Island

St. Helena Sound

ACE Basin
National
Wildlife
Refuge

Hunting Island

Combahee R.

St. Helena
Island

Penn Center

Seabrook

Beaufort

Port Royal

Parris
Island

Beaufort R.

Port Royal Sound

Pinckney Island
National
Wildlife Refuge

Hilton
Head
Island

Calibogue Sound

N

Savannah R.

Daufuskie Island

Savannah National
Wildlife Refuge

Tybee Island

Georgia

95

17

Savannah

Cape Romain
National Wildlife
Refuge

Contents

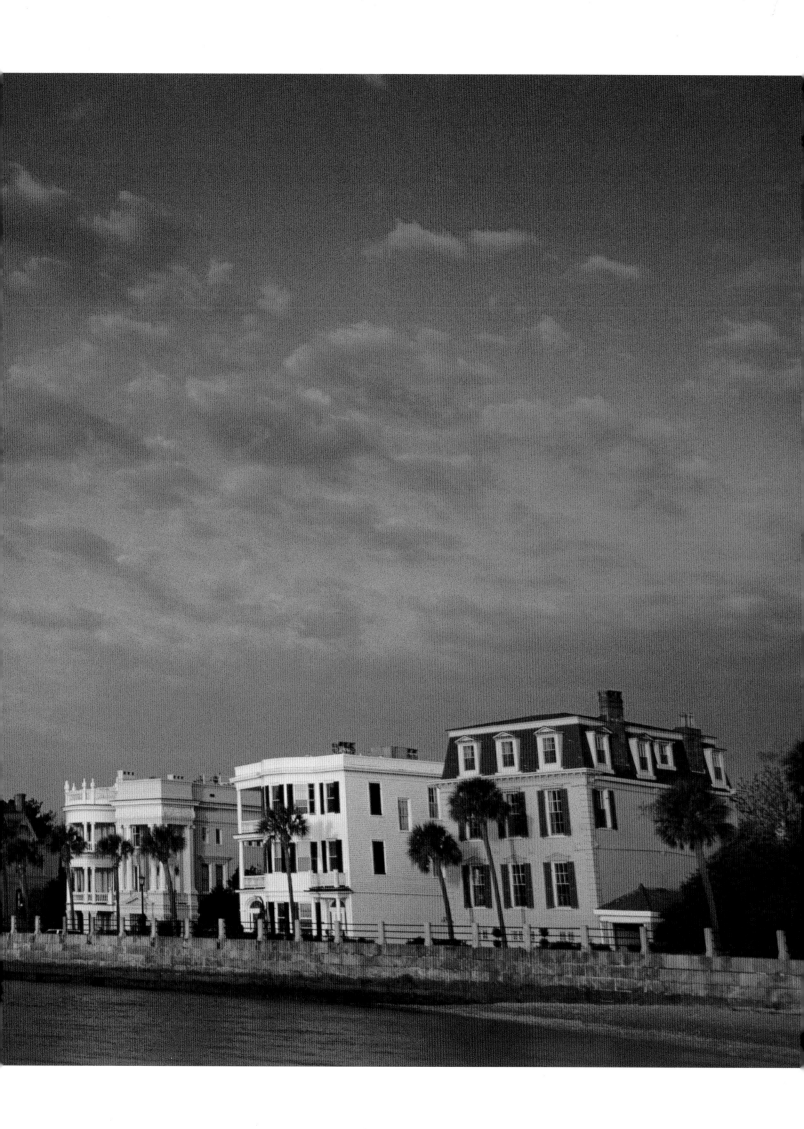

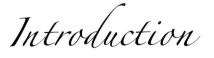

Introduction

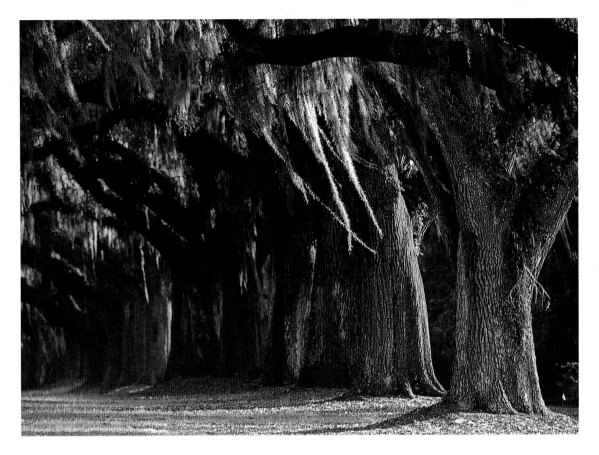

One day a pair of chimneys in an old Lowcountry plantation house gave way. The mortar between their outsized handmade bricks had turned to dust, and the weight of the beam that rested on their flanking piers (a span on which the upper floors relied) was finally too much to bear. Their broad bases trembled as stacks of brick came loose. In the days and months that followed, workmen proceeded cautiously and the contractor and the consultants compared notes. The outcome could have been worse, they agreed, and should have happened sooner. The partial collapse was the result of built-in

❧

▲ The live oak draped with Spanish moss symbolizes the Lowcountry and its characteristic qualities—strong and soft, resilient and sensuous.

engineering blunders and decades of ill-conceived corrections. What had allowed this house to stay upright for two hundred years was the quality of the materials used to build it and the craftsmanship of slaves and laborers whose work brought a delicacy of form to its mass. That is, its survival was not entirely rational.

In the following months, while the engineers despaired of these nineteenth-century builders, wondering, "What were they *thinking!*" I wondered, "What *were* they thinking?" As they reconstructed the pieces and set the house to rights, I attempted to reconstruct the hazy lives that had turned those pieces to use, that had made that house a place. I wanted to bring my own sense of order to the inchoate past.

The house appears to be anything but fragile. A foursquare clapboard structure, set up on a high foundation, it makes a blunt statement. It is beautiful and dominant. It brings definition and a point of perspective to the flat, sandy countryside. Yet because it had been made in pieces in the yard and assembled like a puzzle, it had a hundred points of weakness, a hundred places where an assumption, over time, evolved into a mistake. If there had been a drawing to guide its construction, no mention of it was made in the owner's journals. Instead there were lists: nails purchased, names of slaves, numbers of livestock, wages paid, rum allotted. It was meant to be a useful house, big enough to accommodate the typical domestic and financial dreams of a newcomer. It was like many others put up in those days.

That it became special, of course, has to do with the dimension of time, and all that the passage of time bestows. For one, it lasted. But it also became part of a process that makes something more than the sum of its parts, the process that makes houses and landscapes absorbent. Places do not just get old. They become humanized by all the dreams, ambitions, joy, and heart-break that were played out there and the complex web of relationships brought to life as a result. They are not only scantling and lath and purpled glass and thousands of feet of feathered-edge floorboard. If a house has one thousand visitors over time, the impressions of the one thousandth-and-first visitor are informed by all those who came before him.

This house and the Lowcountry of South Carolina and Georgia of which it is a part are unusual American places. Because they have been lived in for so long, they come with a narrative. Because that narrative draws its power from some of the deepest myths of American history and culture, it matters. Those who visit and "read" these places do so in many different ways. There are clues to decode, and they are everywhere. Some people will cast themselves senti-mentally in the past. Others will see the beginnings of a class and a culture from the first enterprising pioneer. Still others try to locate a family connec-tion made invisible by slavery. Each one engages in a dialogue cued by his own experience. It is easy to feel the presence of the past, to imagine access to the thoughts of those who once lived and worked here. It is an intimate thrill. And like all intimacies, it can be deceptive.

The time came for permanently securing the chimneys. A pair of two-ton jacks and a scaffolding of bracing boards had relieved them of their load. The basement floor had been ripped up. What was left was cool, damp sand. As

Places do not just get old. They become humanized by all the dreams, ambitions, joy, and heartbreak that were played out there and the complex web of relationships brought to life as a result.

To understand a place and its past, this journey that commences with an object or a historical fact, and travels through memory and imagination, is fine, so far as it goes.

❧

▶ *Imagining life in the past requires little effort when light, design, and a sense of place conspire in a single location.*

the workmen raked and leveled they unearthed hundreds of artifacts: bottles with thick necks, rusted hinges, belt buckles and buttons, china dolls, pennies, pieces of porcelain, and parts of stout jugs. Each fragment seemed to suggest a path straight back to an owner and a use. As I picked them up, turned them over in my hand, I felt I knew that house in a way I never had before. I connected. I had it figured.

I had experienced this feeling before, in the rural island landscape of which this house is a prominent feature. There, the evidence of the past often ended in a destination: a faint roadbed leading to a long-gone settlement, a pair of rotten pilings conjuring a pier, rows of neatly planted oaks that marked a now-forgotten entrance. But these basement remnants, so stunningly specific, so familiar and domestic, seduced me into thinking I could reconstruct a sense of place just as easily as I could mend a broken vase. That is, as the house was being physically put back together, what I came to call its own life, as represented by its leftovers, could be similarly reconstructed.

And just when I was at my surest, I was brought up short. Eager to see what I considered the heart of the house, the base of the biggest chimney, the place where perhaps the first brick had been laid in 1800, I looked along the deep trench abutting it. In it lay two objects. One was a small hand-carved boat, neatly detailed with a tapered hull, a narrow gunwale, notches for oars, a center mast, and a rudder. When touched, it shed flakes of ochre and blue paint. The other object was flat, carefully shaped and sanded, about nine inches long and three inches wide. Held vertically, it resembled the human figure, with an oversized oval for its head, such as I had seen in African museum objects. It rested comfortably in my palm and had the feeling of a handle, although someone had taken great care in making it delicate and stylized. There seemed to be traces of surface decoration and tines. Was it a comb? Something to weave a net? The one implement for eating a family might have had?

Here was no straight line. Here were objects so unfamiliar they had escaped my imagination and had uses I could not pin down. And how would I know their owners? Were they left intentionally? Were they symbolic of something, and buried to protect it? A memory of a life left behind? A charm? It is unlikely that anyone but a slave would have been digging ditches three feet deep to set a chimney. And it is unlikely that a slave, with little else to call his own, would have carelessly lost a lovely toy boat or a useful utensil, if that's what it was.

To understand a place and its past, this journey that commences with an object or a historical fact, and travels through memory and imagination, is fine, so far as it goes. But I realized it can never go far enough. There will always be something just outside the line of vision, something that can't be calculated or measured, some accident not taken into account that makes a mockery of full understanding. Anyone who visits the Lowcountry will discover a remnant world: in Charleston, Beaufort, or Savannah, dense with astonishingly beautiful buildings; in rural areas like Edisto or St. Helena Island, horizontal landscapes of ploughed fields and watery vistas. And, very likely, there will be someone nearby with a story to explain it. But there is

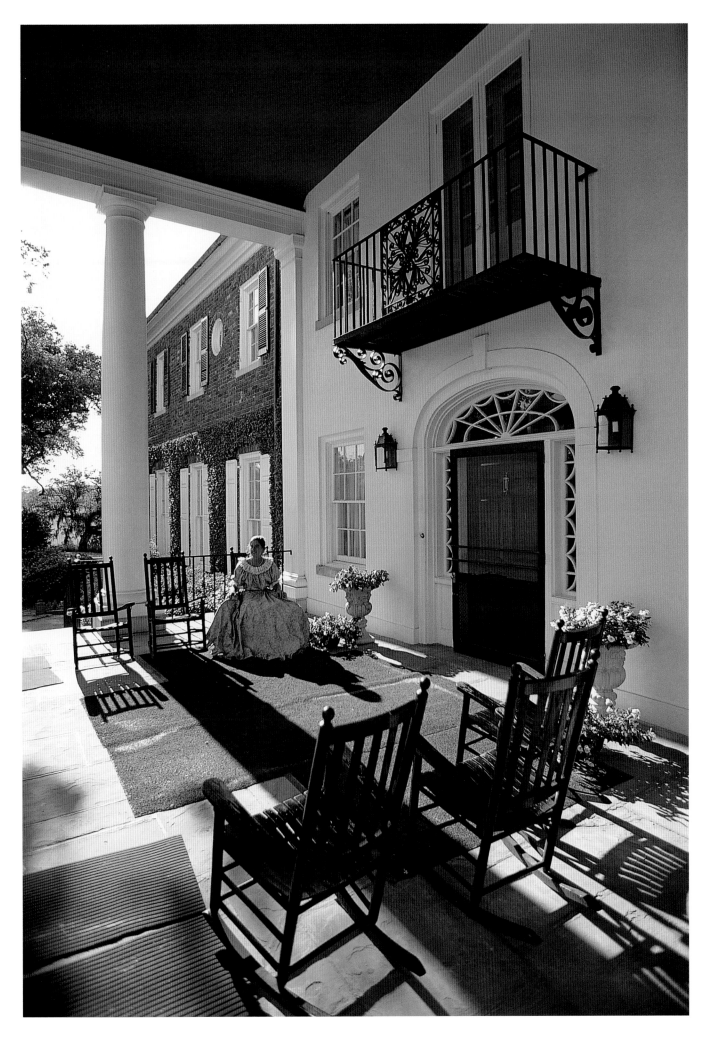

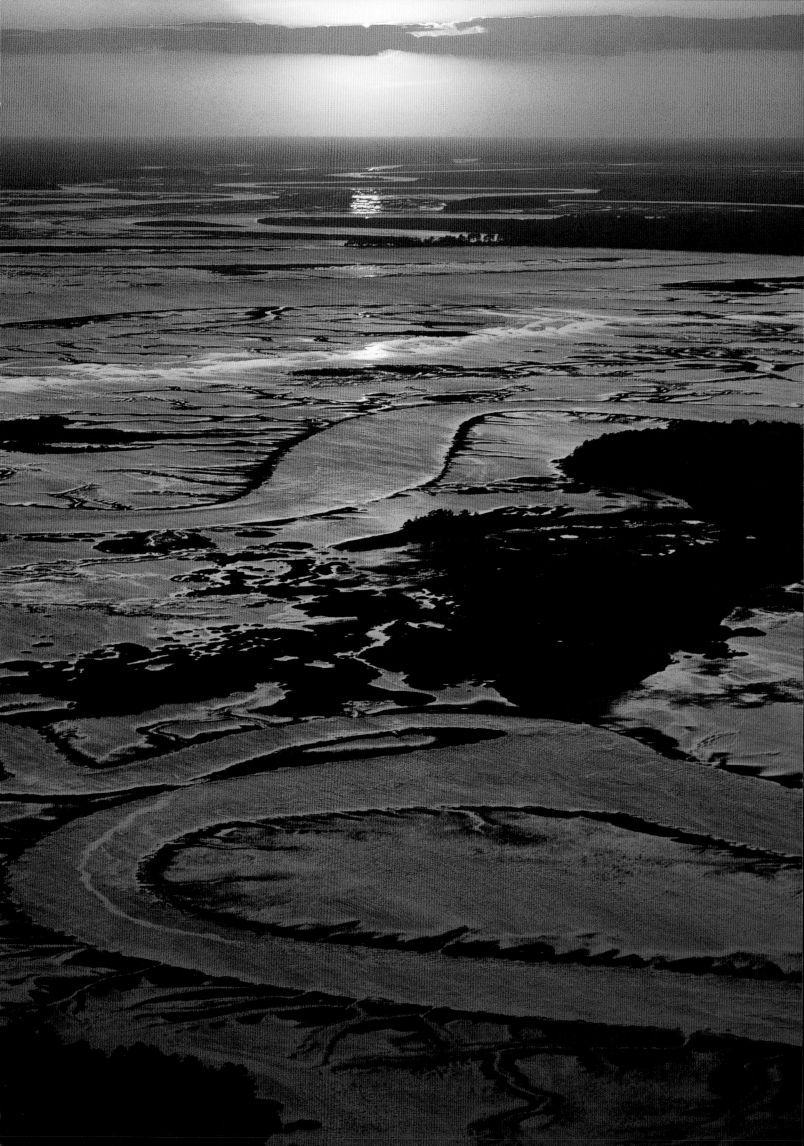

power in what's not so easily seen or made sense of—the enticement of a clue. This is what makes the region different, so that you will say to yourself as thousands have before you "this is a place that could exist nowhere else." To appreciate the Lowcountry is to realize that its meaning lies between the tangible and the intangible.

Thus, this book is not just about seeing but about a way of seeing that is informed as much by the depth of your need to know as by what is there.

<center>

❧

</center>

The section of the East Coast known as the Lowcountry is generally agreed to run approximately from Charleston, South Carolina, to Savannah, Georgia, and to include more than one thousand islands, some as large as Hilton Head—about thirty thousand acres and twelve miles of ocean frontage—and some as small as Friendship, which can be circumnavigated after a picnic. A recent study by the South Carolina Coastal Conservation League mapped more than seven hundred islands in Charleston and Beaufort Counties alone. Some are large enough to build a house on; others support only nests. But while the Lowcountry is best known for its saltwater geography—sounds and wide rivers and estuarine systems that snake through it—the area reaches inland, beyond the old rice fields and bottomlands, to the place where the tides are not measurable. By today's maps, the Lowcountry runs west from the Atlantic Ocean to Highway 17, the old inland road, to include towns like Jacksonboro, Coosawhatchie, and Pocotaligo.

If there is not an exact boundary to mark the Lowcountry, that is because the lack of edges is a characteristic of the area. The ocean reshapes the shoreline every day. The marsh floods and drains. Sandbars rise up in the creeks and rivers, and channels cut through them. At any given moment the Lowcountry is expanding and contracting. It feels like one huge ecosystem whose basic elements—water, air, light, earth—blend together and affect one another seamlessly. There is always motion, always weather, always the sense that the region is being shaped and reshaped. The land mass is fungible.

It has been said that there are so many miles of shoreline in the Lowcountry that no accurate accounting has ever been made. Except in the case where the ocean meets the beach, and the view is linear, the eye is directed to miles of twists and turns as rivers flow to the big sounds. The ACE Basin, comprising the Ashepoo, Combahee, and Edisto Rivers emptying into St. Helena Sound is one such system; the network of smaller rivers that run to the Broad and then to Port Royal Sound, is another. This striking aspect can be seen from any bluff or any boat: you needn't fly in a small plane to feel the complexity. Where the water in the creeks runs like a maze, enfolding you, gathering you in as it approaches an outlet, the change is vast and sudden. There is a spot in Beaufort County where Village Creek joins the Morgan River. Here the difference in bodies of water is as startling as the difference between a winding, wooded mountain path and the alpine valley that opens up on the other side of the pass.

Of course, not all water is the same. There is the still and brackish type,

The Lowcountry . . . feels like one huge ecosystem whose basic elements — water, air, light, earth — blend together and affect one another seamlessly.

<center>

❧

</center>

◀ The buffer zone: ribbons of meandering creeks and tidal rivers cut through the marsh and flow to the ocean, creating one of the country's richest marine environments.

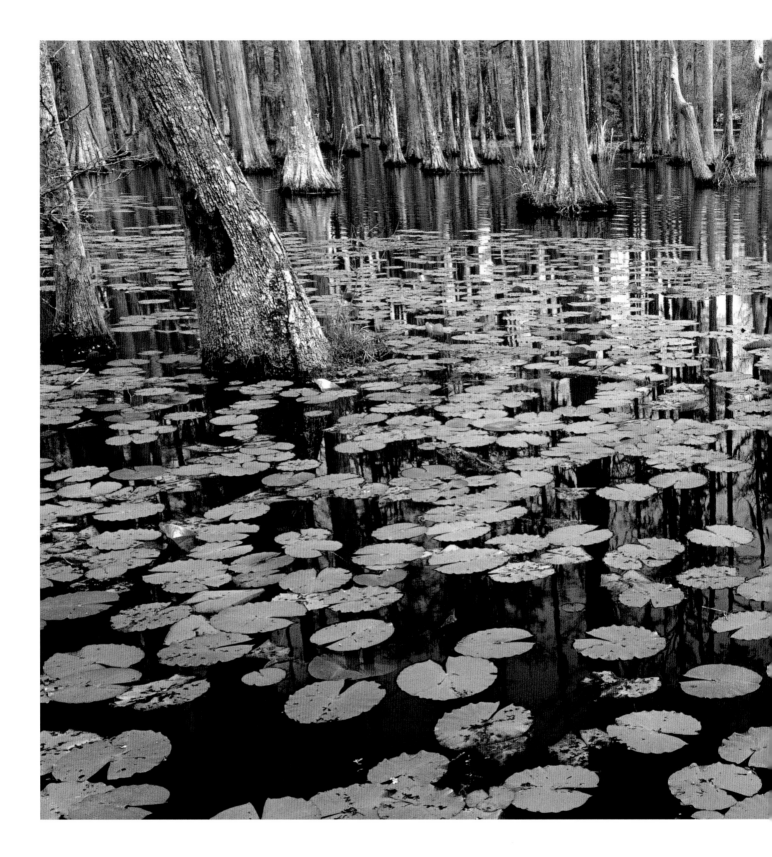

▲ *The still, patterned beauty of Cypress Gardens, nestled in an old rice plantation reserve you can paddle into, feels ancient and primeval.*

found inland, in the former rice fields that are now diked and sown to attract migrating birds. There is the blackwater section of the Edisto River, the color of dark copper. In the shady tupelo and cypress swamps west of Charleston, bright green algae film laps at the knobs of the trees. There is the surf of Kiawah or Hunting Island or Edisto Beach. There are the creeks and inlets where the rush of water when the tide turns is so strong that, in seconds, it can pull a shrimp net from your hands or pull a swimmer under.

The air. The air has its own presence. It can be so heavy, so dense with

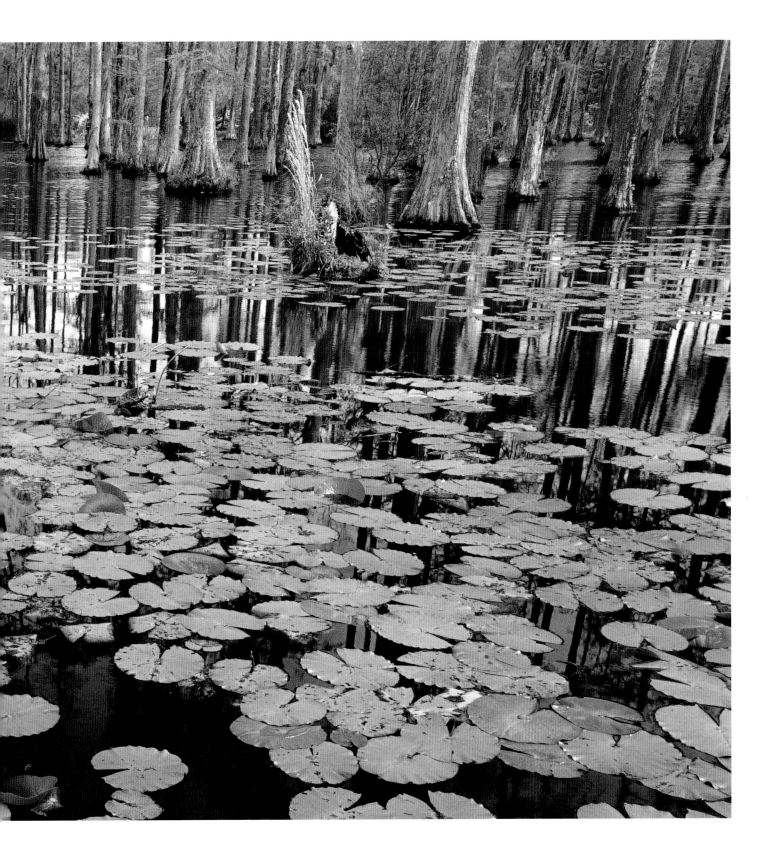

moisture, it seems to bear down on the earth. At times like this it is full of volume, practically sculptural. Before a sudden summer thunderstorm, before the lightning busts it open, the air encloses the Lowcountry like a box. Then in late October, a funny thing happens. It's as if a whole new shipment of air is delivered. The old, heavy air clears out. There is more room, as if a heavy quilt had been thrown off, and your arms and legs are free. This is the soft air of autumn, through Christmas, suffused with golden light. It's the air that carries heavy morning dew. And then during what passes for winter, *(to page 17)*

❧

▶ *Resort development on the barrier islands has become environmentally sensitive, even as thousands of acres are cleared for championship golf courses.*

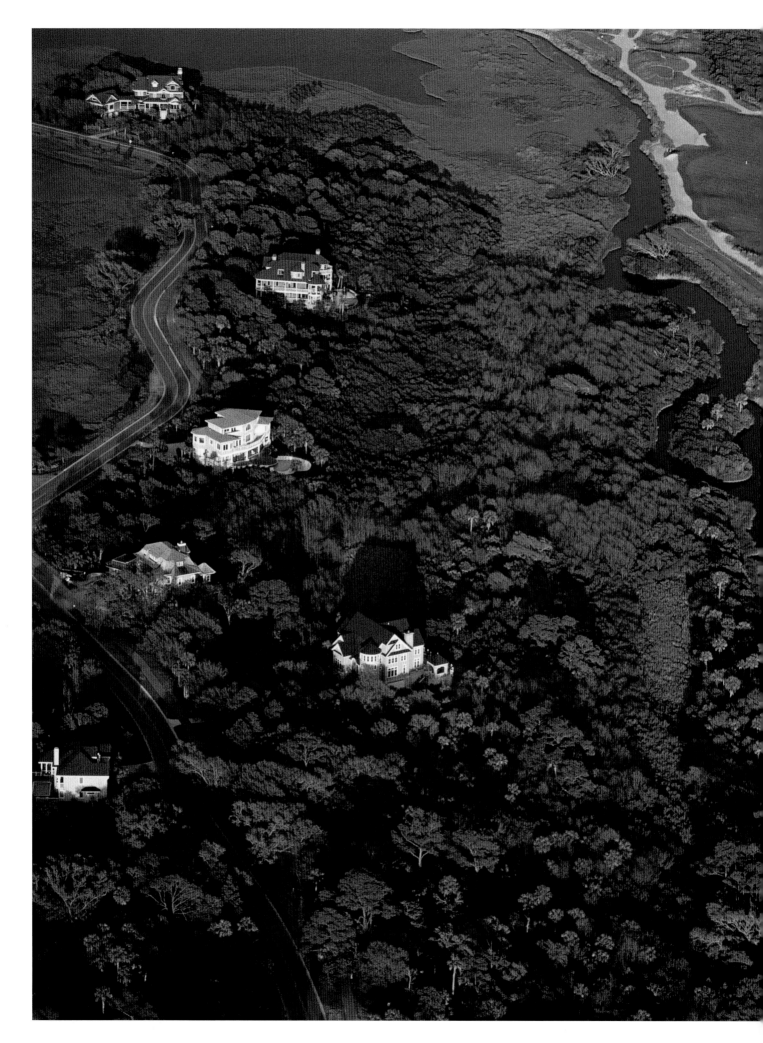

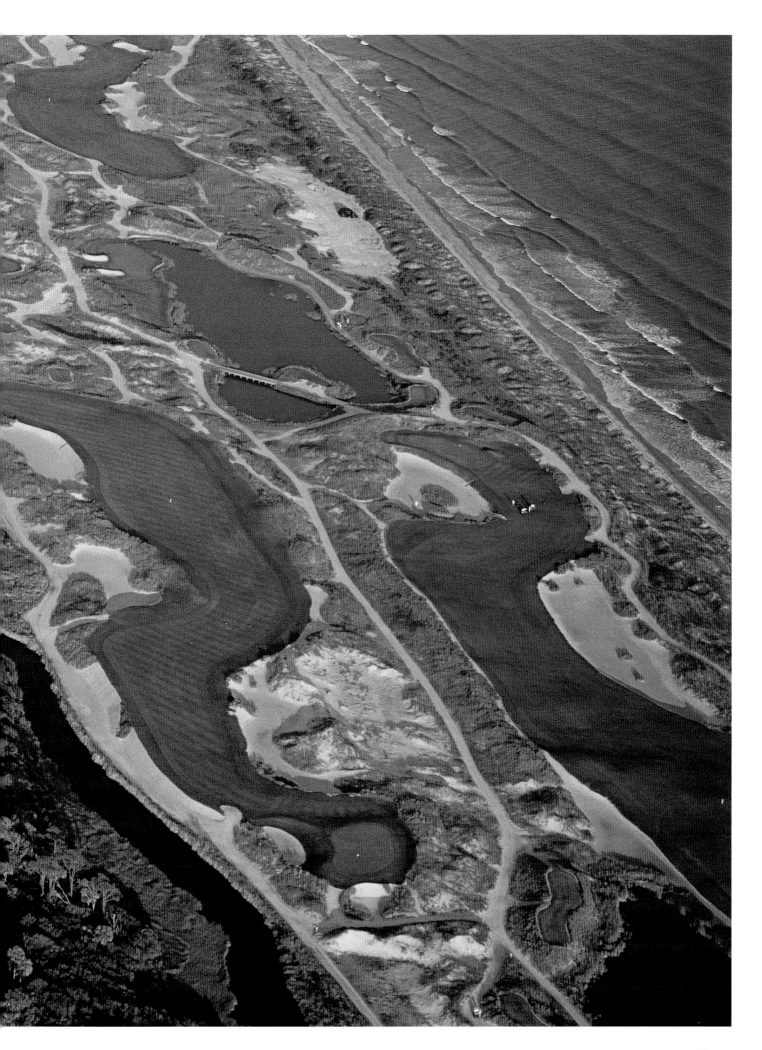

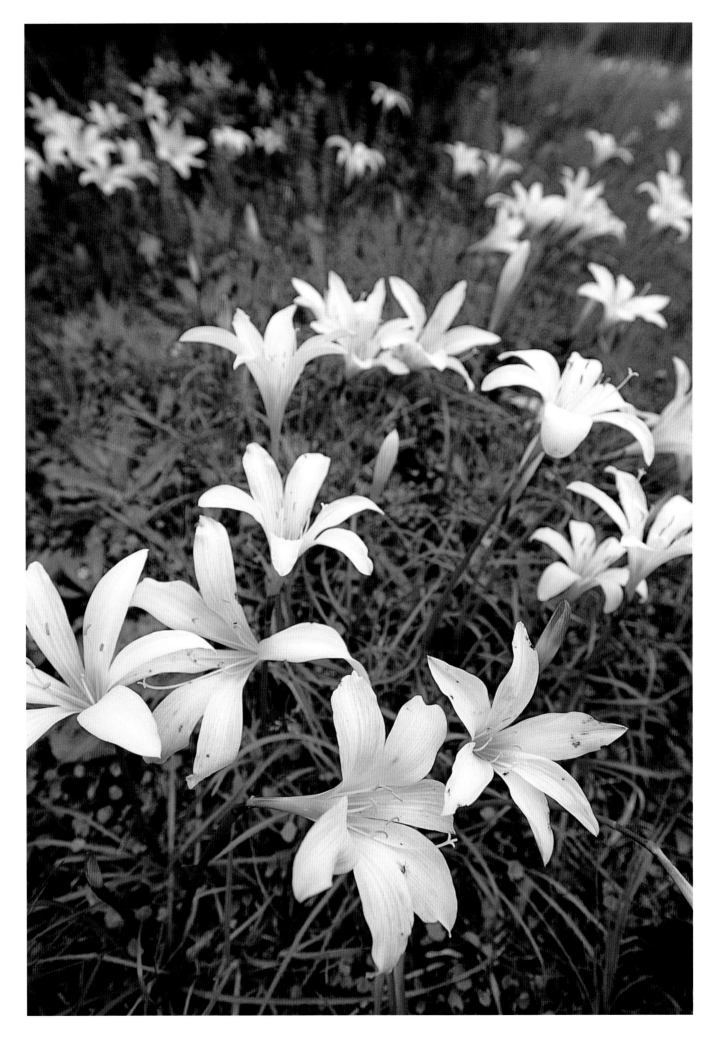

(from page 13) January and some of February, it fades, becomes a little thin, anemic. It lacks texture. It can barely carry the light, which at this time of year can be bleak and gray. The air changes again when the temperatures rise in spring, until late May, before the still, humid heat of summer. At this time the air is swirling with yellow pollen, falling dogwood blossoms, sandy soil kicked up from the ploughed fields, and smoke from small brush piles as residents clean their yards and prune their trees. There can be warm or cool pockets, clammy spots near a wall or a drapery of fog where the temperatures collide.

Like the air, the Lowcountry light varies in intensity over the year. Its purpose changes. In the major growing season from March to October, when the sun is high in the sky all day and sets quickly and dramatically every night, the colors are practically unnatural. It's as if someone lit up the floods and called, "Action!" The marsh grass turns a blinding green. The color of sycamore bark, usually a mottled shade of gray, is punched up to a palette of tans, buffs, browns, and blacks. The tender new growth on pecan trees and holly bushes is nearly fluorescent. A white camellia or azalea will be the standard by which all other whites are judged—and they will look dirty by comparison. The absence of daylight brings starlight and a sky that is so blue it's nearly black.

The physical landscape upon which the other elements impress themselves is flat, sandy, and free of rocks. While the soil seems more gritty than loamy, what thrives here thrives like crazy in the moderate temperature. Native seeds, spread by the wind or birds, "volunteer" themselves into the ground and become hedges in short order. A field left unmowed for two years will resist a mower again until the underbrush and growth is cleared with a bush-hog. Pine trees can be planted and harvested for pulp in fifteen years. At some older homes in the country, paper white narcissus and daffodils have naturalized in such numbers that clumps of flowers have become carpets. In Charleston, wisteria vines thicker than a man's forearm tumble over brick walls.

What is true of the Lowcountry today has always been true. The earliest French, Spanish, and English explorers remarked on this intrinsic power, where cause and effect were so closely related—to be ignored at one's peril. For where there were life-sustaining food resources, opportunities for export, and a temperate climate conducive to settlement, there were also natural hazards: blistering heat, flooding, malarial mosquitoes, lack of fresh water, and wildfires that jumped the marsh. The Native Americans who preceded the Europeans had adapted. They navigated small canoes up the tidal creeks, found the springs and freshets that bubbled up through the aquifer. They migrated between the coast in summer where they could fish and farm, to their protected inland villages in winter, near hunting grounds.

These days, mechanical systems like central-heat-and-air moderate the Lowcountry's extremes, making us believe we are immune. But just as we cannot avoid the history of the region, neither can we avoid its dramatic natural power. If nature gave the Lowcountry its character, history gave it its choices. These forces together have made it what it is today. They have left nothing untouched.

Like the air, the Lowcountry light varies in intensity over the year. . . It's as if someone lit up the floods and called, "Action!" The marsh grass turns a blinding green.

◄ *Masses of flowering bulbs, many of them planted when Thomas Jefferson was president, have naturalized around plantation houses, churchyards, and cemeteries.*
► *Each old house in Charleston tells a piece of its story—of how it started, what it hoped for and became, what it lost and what it has found again.*

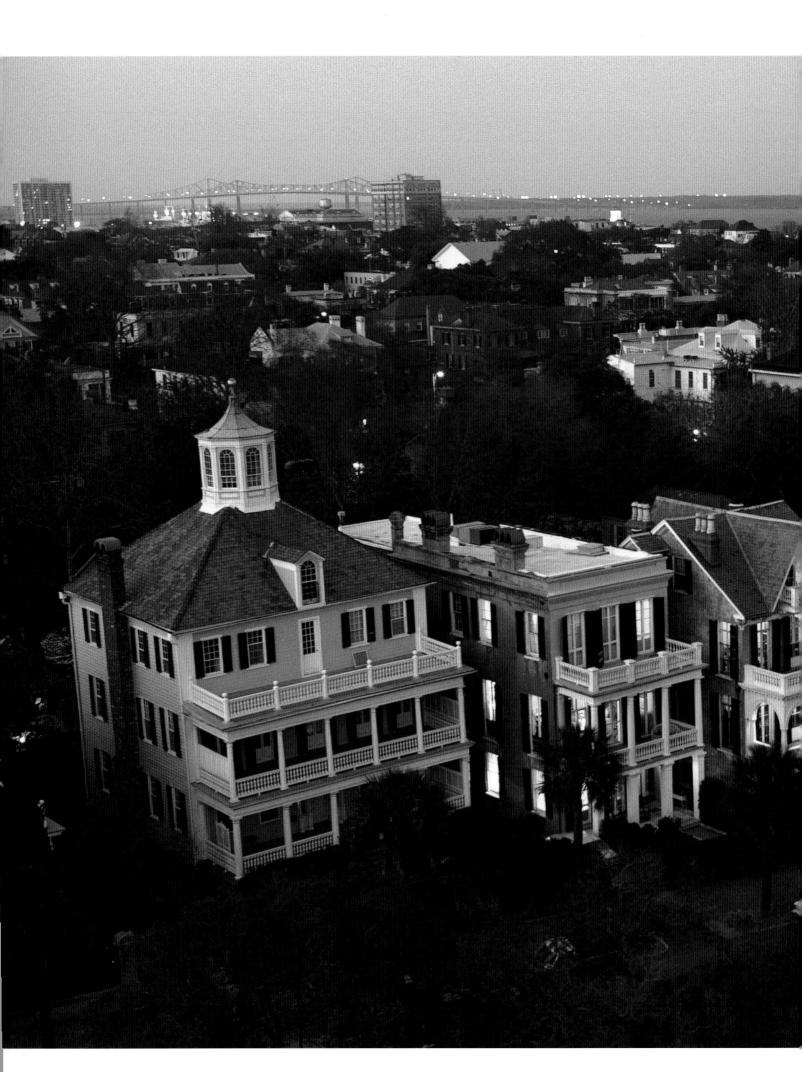

CHARLESTON

CHARLESTON

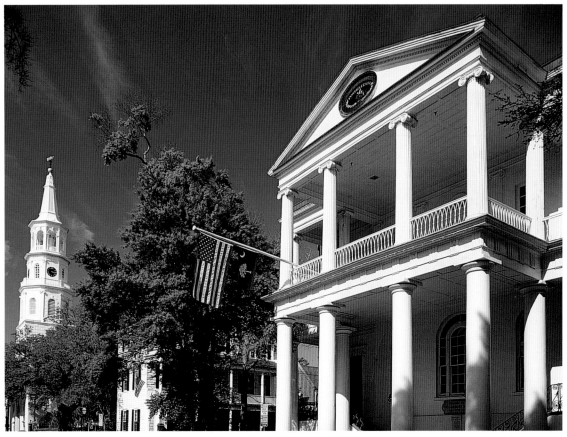

Charleston has long considered itself the center of a world, a place apart, with all the detachment, self-regard, and romantic isolation that come with the condition. Like a child of privilege raised to feel both responsibility and rank of honor, Charleston has never quite lost that sense of itself, despite setbacks that would have forced introspection on other cities and caused them to revise their thinking. Neither the British occupation during the American Revolution, the bold act of secession, the humiliating Union defeat,

❧

▲ *An embedded commitment to church and family, and a sense of Southern pride passed forward through generations, have allowed Charleston to weather reverses of fortune and emerge as a vibrant city.*

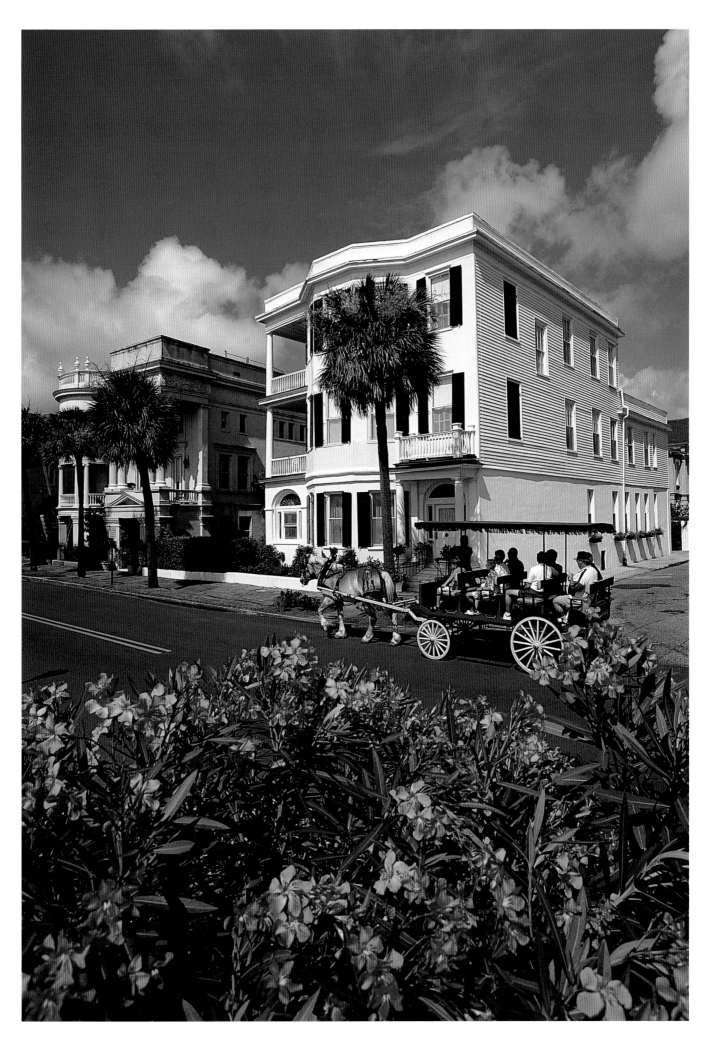

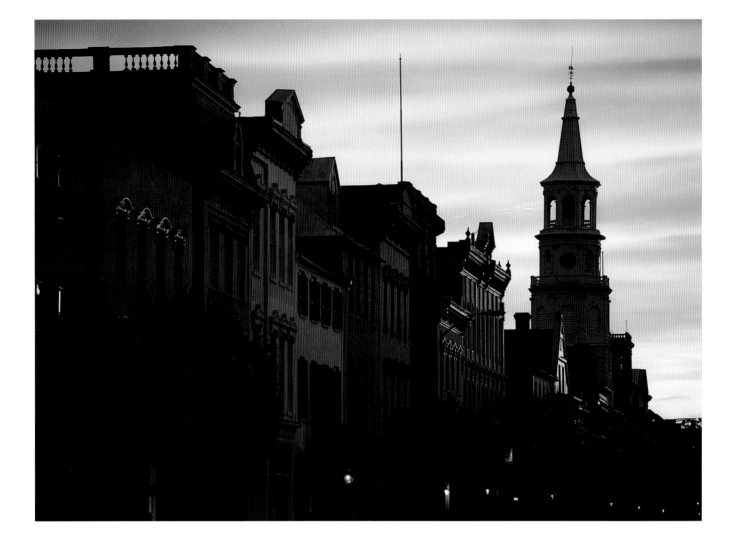

nor the years of poverty that lasted well into the twentieth century has been able to shake Charleston's confidence.

Even today, it is only half in jest that people in peninsular Charleston comment that its defining rivers, the Ashley and the Cooper, join below the Battery "to form the Atlantic Ocean."

To a contemporary visitor this is a refreshing thing. Here is a city without apparent insecurity, with no overwhelming need to remind you of its bona fides and point you in the direction of its plaques. For one thing there are simply too many of them. Charleston has been a vibrant, astonishingly beautiful city for nearly three hundred years and has a deep inventory of urban artifacts and cultural accomplishments to show for it. It is the rare American place whose built environment points to a recognizable and inhabited past. Spread throughout a dozen neighborhoods are hundreds of historic homes, churches, shops, and commercial buildings, some as grand as a South Battery mansion, others cowering under the magnolias behind a brick wall.

And people still live here: teenagers shooting hoops, bankers walking their Jack Russells at lunch, kids heading home in school uniforms, impeccably dressed African-American women leaving church service, guys in seersucker with cell phones looking for a drink in a cousin's garden after work. And as the dusk falls, they'll be eating *(to page 26)*

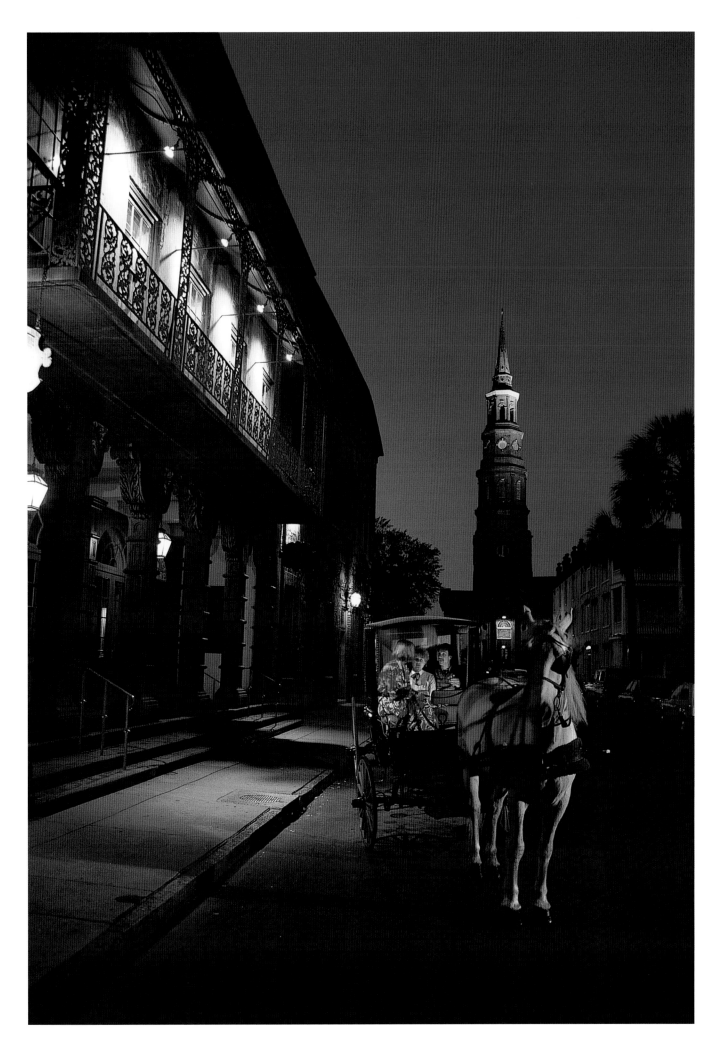

❧

◄ Charleston's preservation efforts began in the 1920s, when local women began a movement
to identify and protect buildings that were threatened by demolition, decay, or architectural gutting.
▲ A temperate climate that favors flowering trees and shrubs like dogwood,
redbud, pittosporum, and wisteria raises gardeners' hopes for public and private beauty.

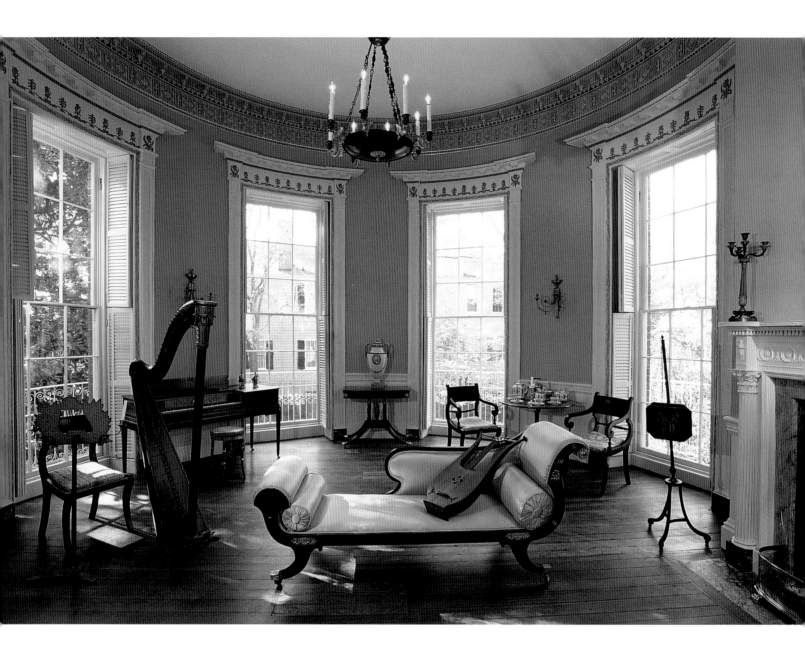

▲ *By the early 1800s, Charleston's prosperity and social stability created a new American elite who established homes like the Nathaniel Russell House, now one of the city's finest house museums.*

(from page 22) boiled peanuts, shrimp paste on Ritz crackers, or cream cheese and pepper jelly sandwiches. Their ordinary routines humanize a city that could have just as easily lapsed into a tableau, become a version of itself, become a museum.

Charleston is also, and has always been, the capital of the South Carolina Lowcountry region. Its reach extends northwest, to the old plantations on the Ashley River; east to the beach villages at Folly and Sullivan's; and southeast to the edge of the Atlantic and the resort developments of Kiawah and Seabrook. Tucked in the river systems and inland swamp forests are nature preserves and semirural spots such as Daniel Island, Cypress Gardens, and Cape Romain National Wildlife Refuge.

Charlestonians have long had a relationship with these outlying areas. It may have started when the city and the country relied on each other for growth and status. The city's fashionable development was made possible by profits drawn from the indigo, rice, and cotton plantations. The successful plantations, just carved out of the wilderness,

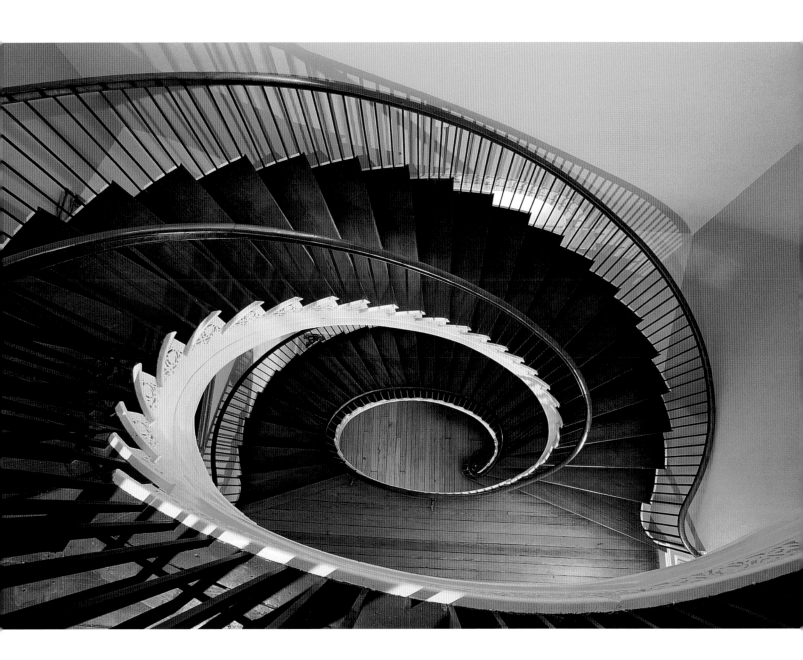

were given a boost by an urban society of shared common interests. They became the family seats of America's emerging class of squires. But these days, what beckons Charlestonians to the country is not a specific place, exactly, but what happens there: gigging for flounder by flashlight, shooting ducks from a blind, sailing, walking the beach, or casting a net. These are the region's enduring entitlements.

The first residents of what was to become Charleston arrived there less than sixty years after Shakespeare died. They were Englishmen or planters from the British West Indies for the most part, seeking to turn their grants of land to profit, and like the Virginia colonists, they brought slaves with them. French Huguenots, Irish, and Scots quickly followed. The population rose as the planters spread out and established themselves, acquiring more slaves every year, and as merchants, brokers, and businessmen flocked to Charleston. Within two generations, all that was necessary to qualify as a first-rate colonial city was in place: land, capital, slave labor and the systematic means to manage it, markets from Boston to Liverpool, and a network of related families to

&

▲ The elliptical "flying staircase" at the Russell House represents the epitome of Charleston's interior architectural refinement.

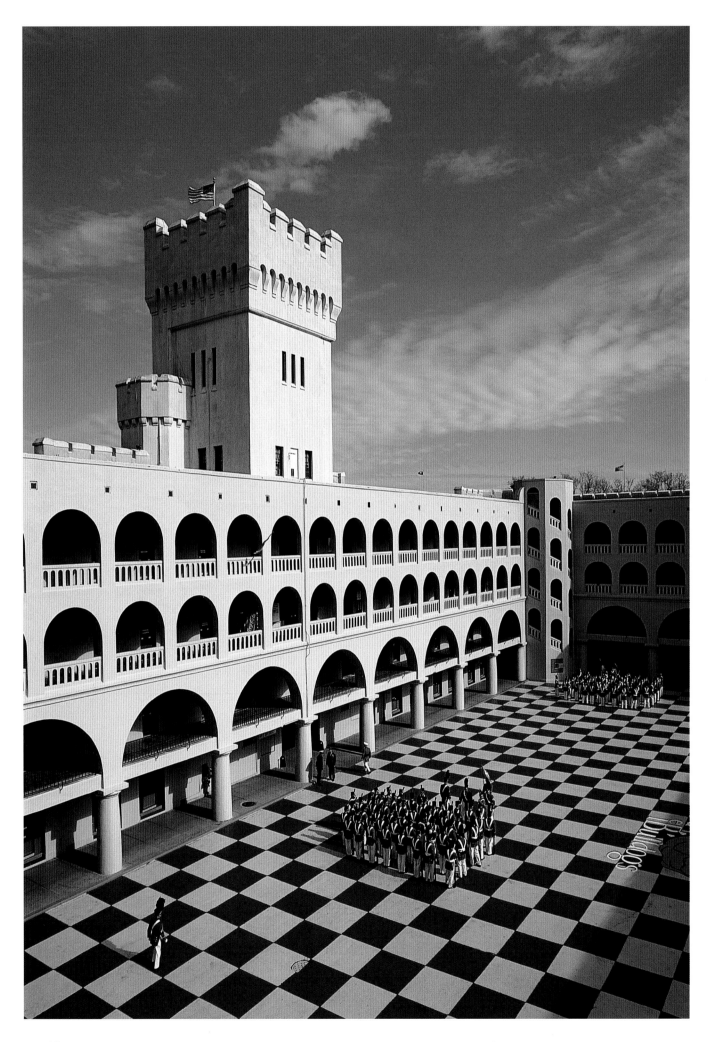

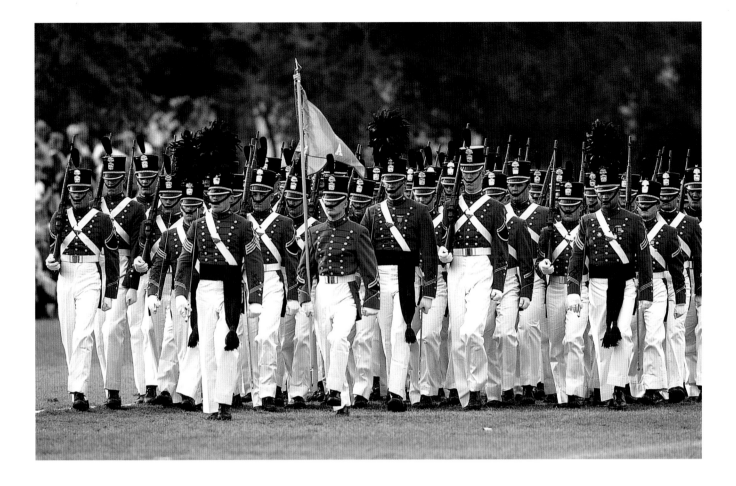

ensure the enterprise ran smoothly and sustained itself. Charleston splurged for one hundred years.

Middleton Place and Drayton Hall, neighboring Ashley River plantations, provide a glimpse into this world. Like the slave cabins at Boone Hall, the gardens at Magnolia, the cruciform church at St. Andrew's Parish, and the Pon Pon Chapel of Ease, they are evocative pieces from the past. The "big house" at Middleton was burned in the Civil War, but what remains are vast, terraced gardens with ornamental lakes, dikes, and camellia allées that were first laid out in 1741 and took untold numbers of slaves ten years to complete. To stroll the grounds, whether or not you visit the museum of family treasures, is to feel you have entered a mural, that you are part of a vision enacted. This is hubris: huge scale, awesome conception, revolutionary engineering and planting techniques, and labor deployed to the cause of beauty.

If Middleton feels panoramic, Drayton Hall is a close-up. Built between 1738 and 1742, it is considered to be the finest example of Georgian-Palladian architecture in America. It is also unfurnished, never had electric lights, has had only one coat of interior paint, and, like Middleton, stayed in the family. This means that your attention is directed to its detailed workmanship: mahogany and poplar carving, plaster reliefs, massive mantels, and patterned masonry. The family silver, although it must exist, is not on display here. Instead, you are pushed to imagine the social and economic momentum that made Drayton Hall a superior product of its time, the momentum

◄ *Cadets stand in formation in the 6,100-square-yard interior quadrangle of the Citadel, founded in 1842.*

▲ *Citadel cadets, both male and female, march in public dress parades throughout the year.*

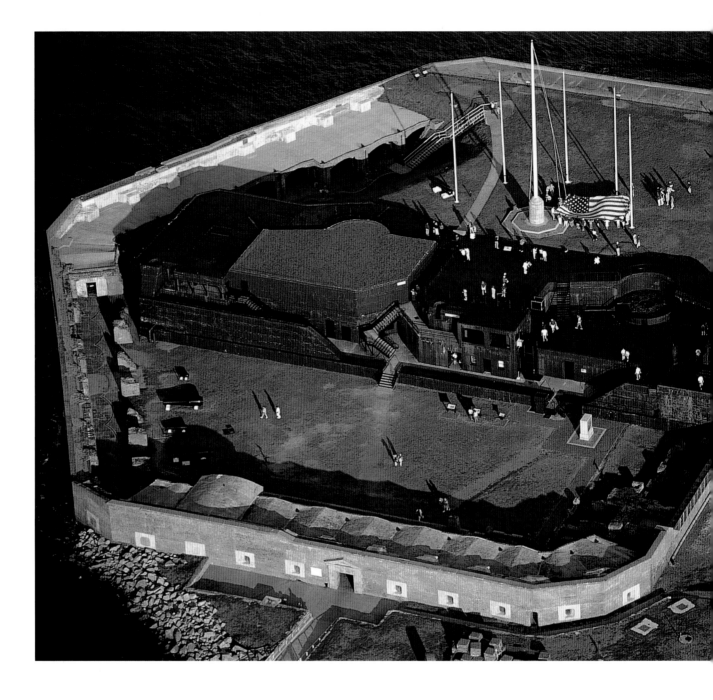

▲ *Fort Sumter in Charleston Harbor was the site of the first engagement of the Civil War: here the first shots were fired.*

that turned aspiration to expression in the mid-eighteenth-century Lowcountry.

The individuals who made this world, who helped bring Charleston to life, are captured in cameo portraits created by a local artist, Charles Fraser. His artwork, in the collection of the Gibbes Museum and usually on display, conveys an enviable sense of social cohesion and stability. He painted his peers and memorialized their settings. These are the families who built St. Michael's Church, St. Philip's Church, and the Huguenot Church, who paid for their bells and pews, who served on the vestry. They supported Robert Mills, a Charlestonian and the first professional architect in the United States, who designed the Fireproof Building and the First Baptist Church, as well as the Washington Monument. Gabriel Manigault, a society scion with a marvelous eye, brought the Adam style to their attention and exquisitely adapted it to their needs in 1803, in the Manigault House

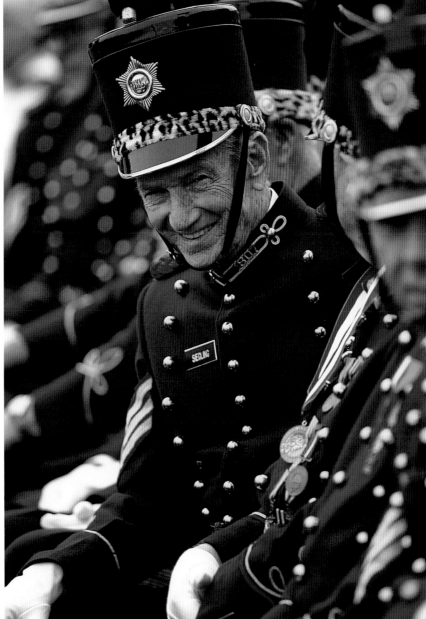

Museum, and one year later in the South Carolina Society Hall. From 1768 to 1775, the gifted local cabinetmaker Thomas Elfe produced some fifteen hundred pieces of furniture for these clients.

These are the families who lived "south of Broad" on the main streets—King, Meeting, Tradd, Church, East Bay, the Battery—and on a dozen cross streets and alleys. Their taste defines the landscape: Georgian, Federal, Greek Revival, Victorian, and in each category a world-class sampling. There are "single houses," which sit sideways to the street (usually entered by a tall, pedimented doorway), one room deep, with two-story porches to catch the breeze and huge shutters to block the sun. Others, like the Heyward-Washington House or the Nathaniel Russell House, face front and give way, behind, to gardens, kitchen houses, slave quarters, and dependencies. Other neighborhoods, such as Wraggsborough and Ansonborough, have their gems. Twice a year, in spring and fall, many of these houses or *(to page 36)*

▲ *Pride in traditional associations, like being a member of the Washington Light Infantry Civic Association of Citadel Graduates, informs core values.*

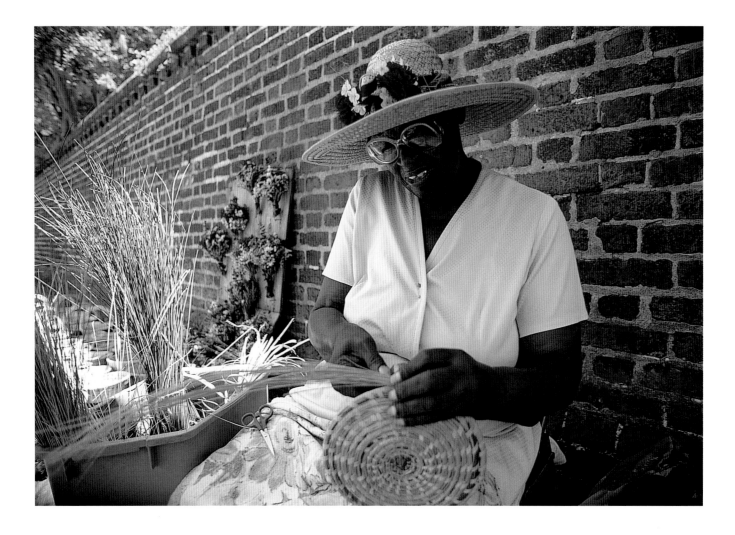

༄

▲ *Gathering native materials and
weaving baskets from pine straw, marsh grass,
and palmetto is a unique art passed down
in African-American families.*

▶ *Sweetgrass baskets for sale in old market
are both decorative and useful, their shapes
based on old designs for storage, "fanning"
rice to clean it, and carrying eggs.*

▶▶ *Market Hall (c. 1841) was for many years
the city's Confederate Museum, filled with
poignant relics like homespun cloth,
uniforms, and flags.*

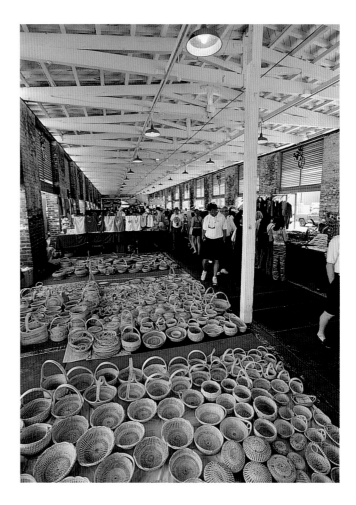

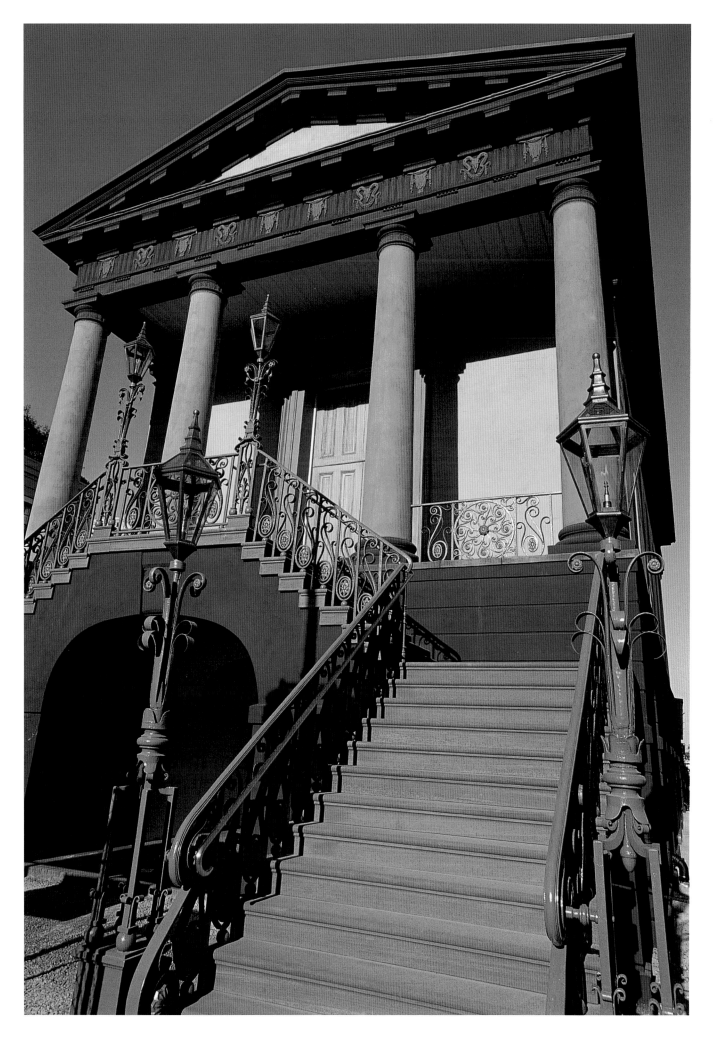

❧

▲ A typical Simmons piece, utilitarian and graceful, is based on
traditional elements of ironwork design that become transformed in his studio.
▶ Philip Simmons is a nationally recognized artist who modestly
admits that "My instrument is an anvil."

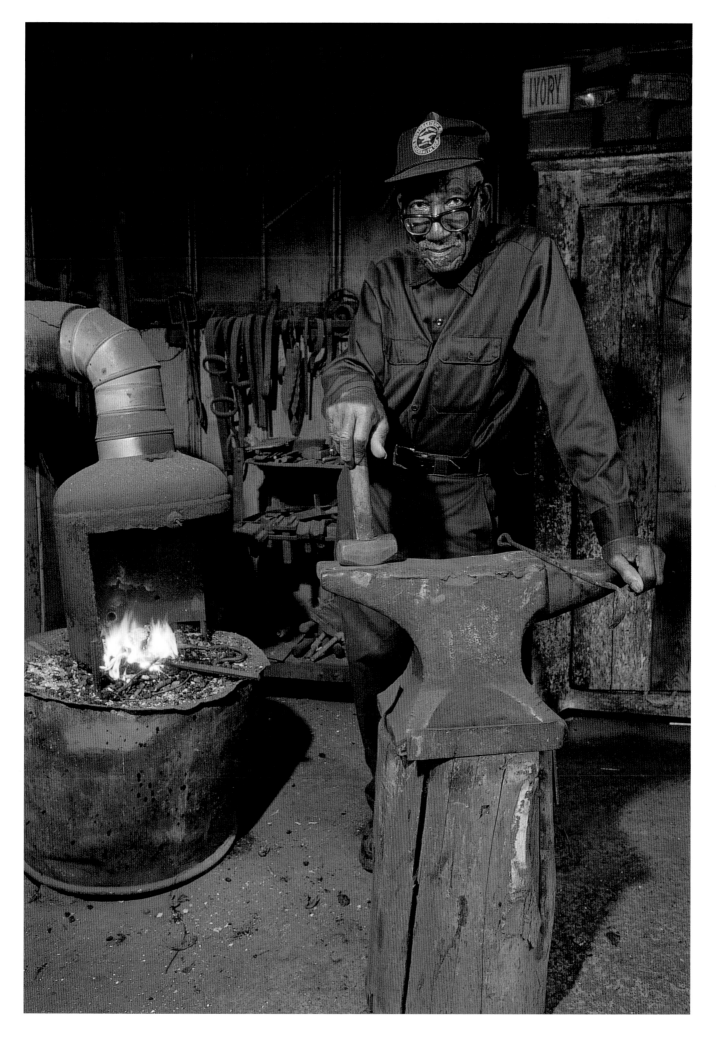

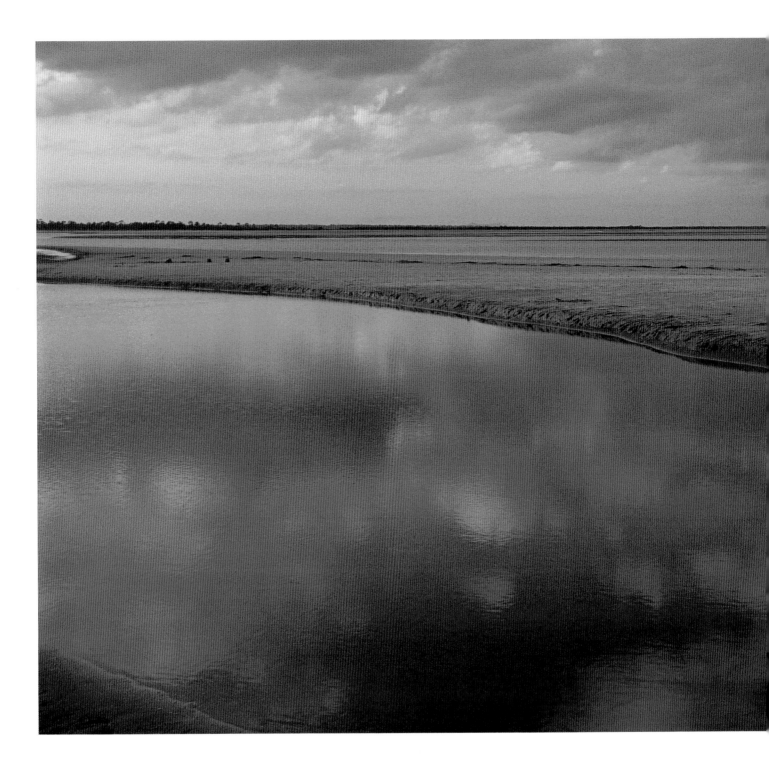

(from page 31) gardens are open on walks sponsored by the Historic Charleston Foundation and the Preservation Society of Charleston.

But it is not only the workmanship of the past, nor English and European influence, that leaves its mark. Philip Simmons is a Charleston blacksmith who has been creating and restoring ornamental ironwork in the city for nearly seventy years. He grew up in a farming and fishing family on Daniel Island, descending from former slaves. He has been honored as a national treasure for being an artist and crafts-man, but what he has also done, far more subtly and for so long, is to bring the old Charleston aesthetic forward with imagination. If the gardens are the background of these magnificent houses, he has defined their foreground, their gates, stair-rails, entries, balconies. He

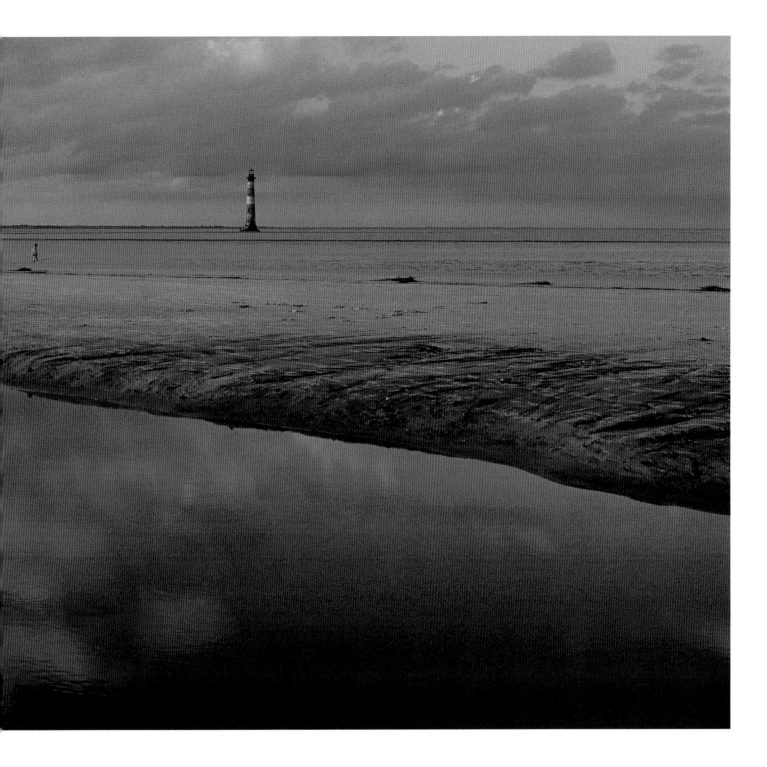

has articulated the distinction between the civic responsibility for beauty, which is a widely shared value in Charleston, and the need to define private space.

For all its self-confidence and proud insularity, perhaps because of it, this is also the world of Charleston that was left behind when the cheering stopped and the Civil War began. What followed were years of poverty, a time when many residents found ways to make ends meet by making do: taking in sewing, letting out rooms to lodgers, growing vegetables to can, and teaching piano in a once-grand parlor on a once-grand instrument. By the 1920s, a growing appreciation of Charleston's architectural significance led to city preservation efforts. Already, some historic houses had been razed to make way *(to page 40)*

(to page 40)

▲ *Tidal waters are usually placid and picturesque, but Hurricane Hugo roiled them to a thundering cascade, pounding Folly Beach, Sullivan's Island, the lighthouse, and downtown.*

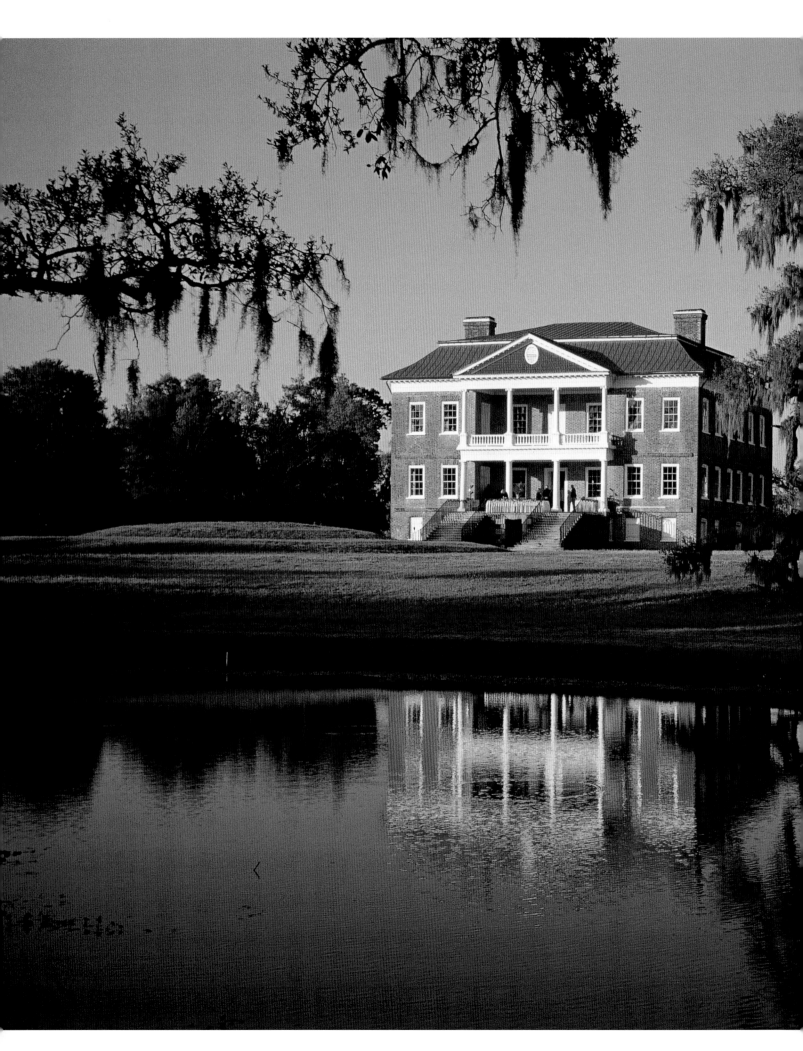

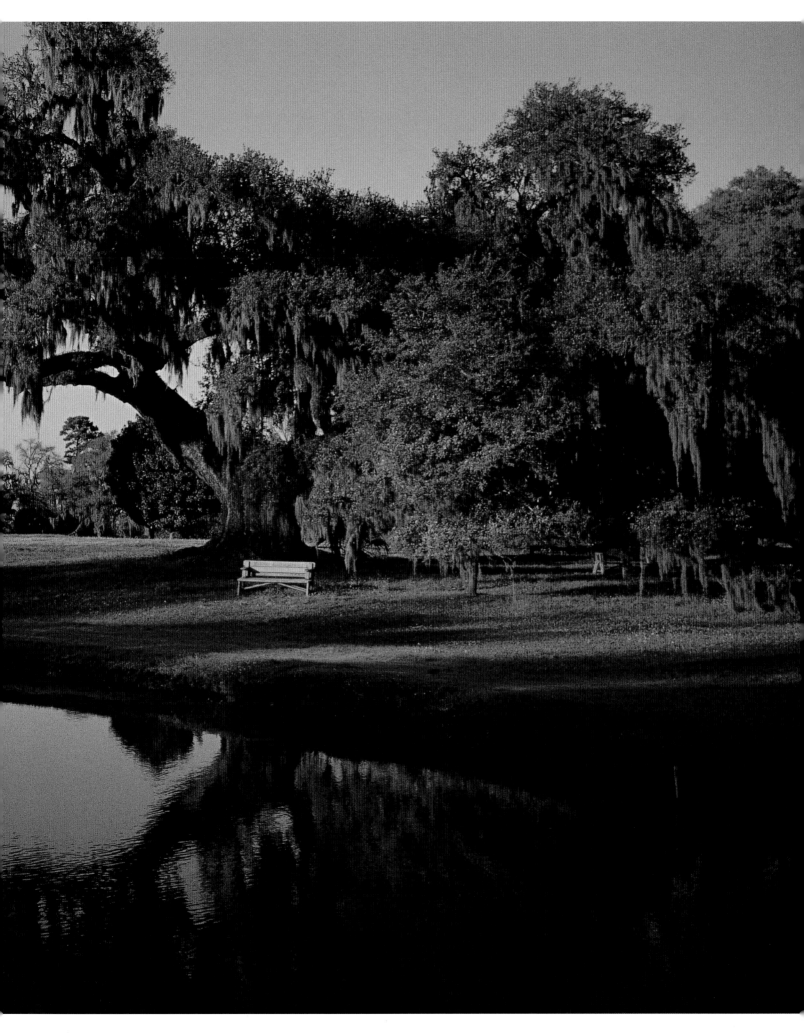

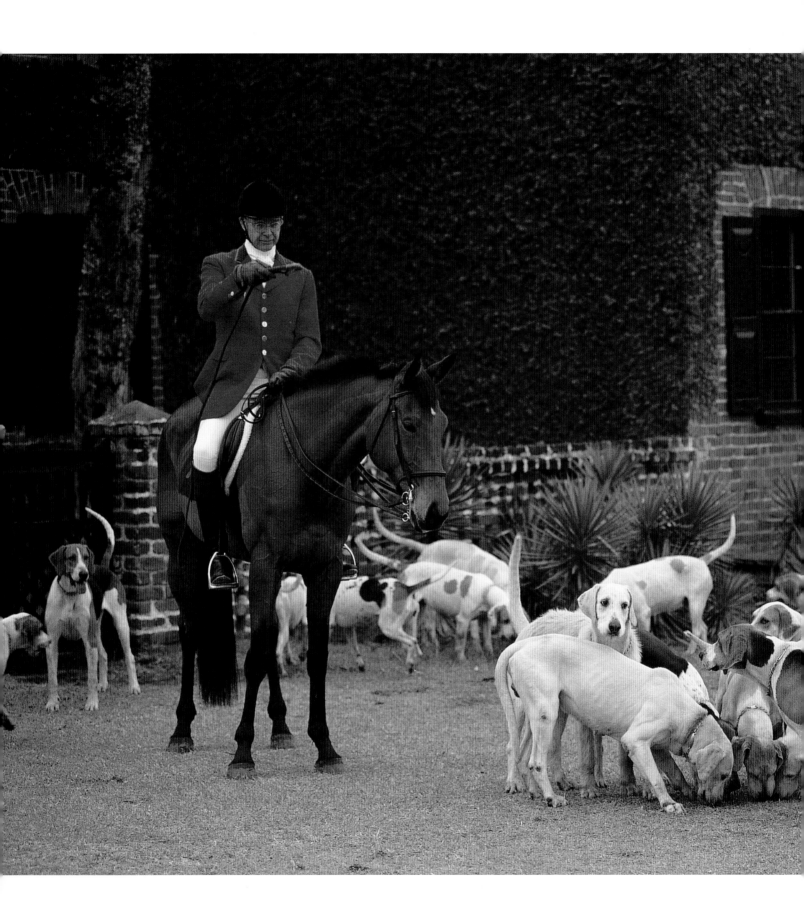

(from page 37) for commercial enterprises; others were being demolished from the inside, with cypress paneling, hand-carved fireplace mantels, and decorative ironwork being shipped off to museums and collectors. At that point, longtime Charleston families organized themselves and determined to be the curators of their own heritage. But it wasn't until World War II and after, that prosperity and the means for preservation

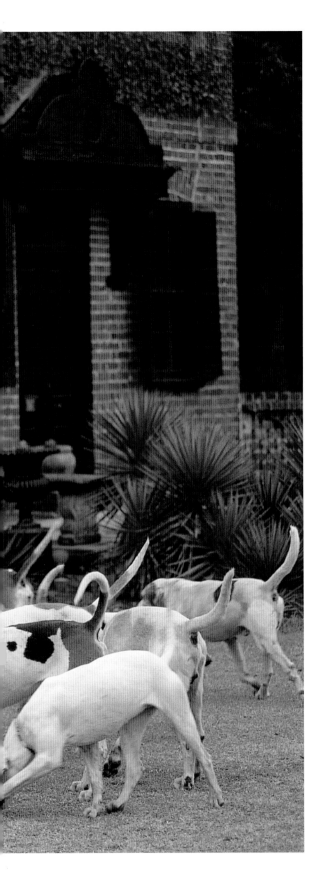

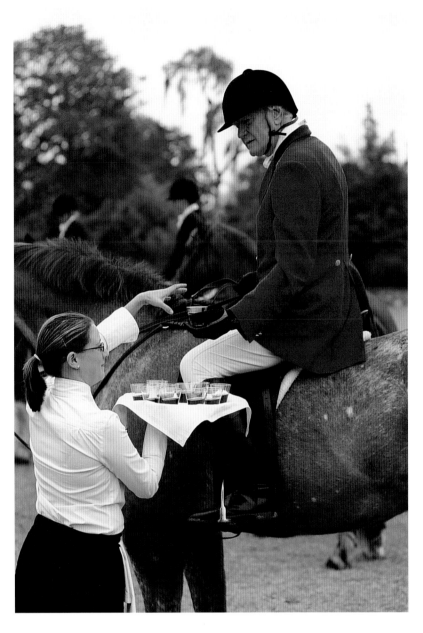

❧

◄ ◄ *Drayton Hall is widely regarded as the
most significant example of Georgian-Palladian
architecture in America.*
◄ *The formal pageantry of Middleton Place
Hounds attracts equestrians as much for the
sense of tradition as for the chase.*
▲ *Hunt breakfasts have a unique menu
based on multiple needs for hearty sustenance,
fortifying spirits, and comfort food.*

☙

▲ *The slave cabins at Boone Hall defined a self-contained community thought to house the plantation's house servants and skilled artisans.*

▶ *With its broad avenue of live oaks, columned portico, and porches, Boone Hall looks like the old South many visitors imagine.*

returned to Charleston. Like many Southern port cities, Charleston was given a boost by federal defense spending on naval installations. Once it got on its feet again, it began to seriously market its past, its greatest asset, in house and garden tours. And when the time came in the mid-1970s to take its turn in the spotlight, Charleston was ready. The spark was Gian Carlo Menotti's inspiration for an American arts festival such as he had developed in Italy. It was called Spoleto.

For nearly three weeks annually in May and June, Charleston is the setting for hundreds of cultural events, from classical concerts and opera to edgy modern art. Patrons flock to hotels and house parties, restaurants extend their hours, and the beautiful old city, fragrant with the scent of jessamine, is on display. If the years have been kind to Charleston, they have also given it time to adjust its inherent self-consciousness to the expectations of the modern age. Spoleto opened Charleston, not just to the outside world, but to itself. Local people opened quirky boutiques, cafés, bookstores, and antique shops. Style borne of a nostalgic aesthetic that had long lingered in the shadows, expressed privately in humor, family hospitality, or arcane manners, blossomed in the rich mix of artists and moneyed out-of-towners smitten with the city. And not just commerce was affected. Once Charleston had a higher standard to live up to, a worldly standard,

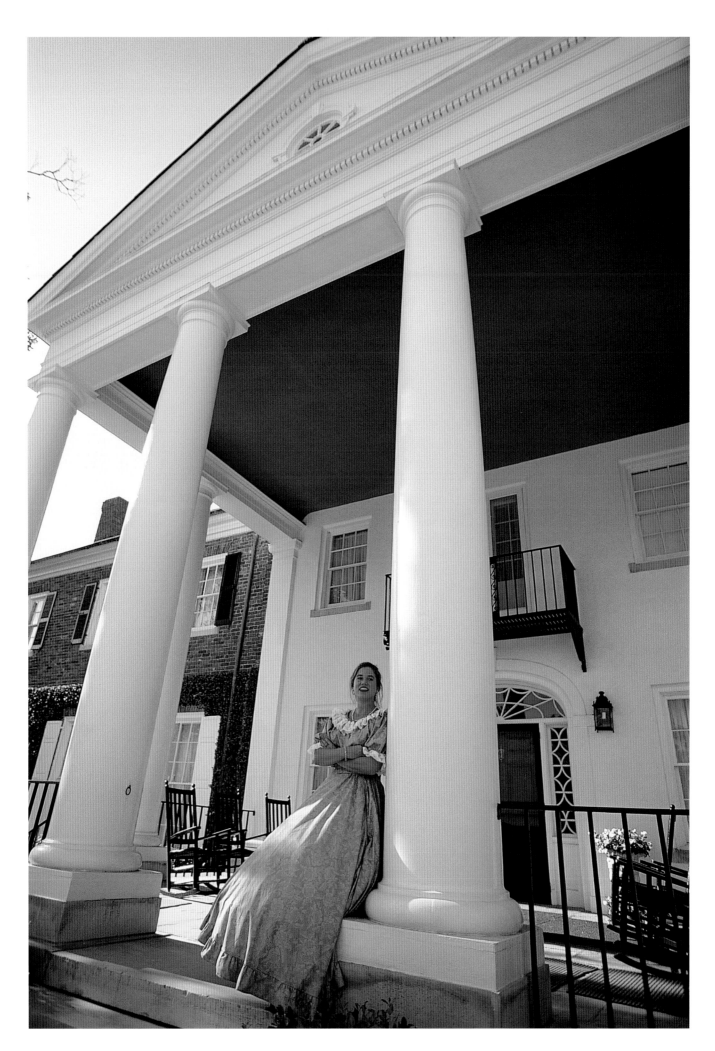

▲ *Drifts of flowering*
azaleas that grow to
twenty feet create solid
walls of color in the spring.
► *Upriver from*
Charleston, the banks of
the Ashley provide food
and protection for
hundreds of species of
birds, and a spongy bed
for lilies and grasses.
►► *The Audubon swamp*
garden at Magnolia
Plantation sustains a
microenvironment fit for
cypress, tupelo, alligators,
songbirds, and visitors.

more attention was paid to its history, less to its myth. This is especially true in an ongoing effort to illuminate the lives of generations of African-Americans and tell their stories in places like the Avery Research Center or the Aiken-Rhett House.

Today antiques stores and fashionable dress shops still line King Street, south of Market, but new ones have opened up to the east, alongside art galleries in the French Quarter. More art galleries have moved to Church Street, south of Broad, one of the city's oldest sections, best portrayed by the pastels and etchings of Elizabeth O'Neill Verner who lived and worked in her studio there for most of the twentieth century. Upper King Street is funky and flourishing, a place where College of Charleston students mix with shoppers at Saks. The old market, with its lovely one-story buildings lined up like an arcade, is mostly given over to vendors who attract the tourist trade. East Bay, from the new aquarium to the Battery, is both the locals' main street and the address of some of the city's best restaurants and newest luxury hotels.

Charleston seems to have learned better than most places how to manage its development and popularity. This is especially true on the Sea Islands, which lie on the outskirts of the city, places like Folly, Kiawah, and Seabrook. It's not just that they are gated communities, or that portions of them are, nor that they are well-manicured *(to page 49)*

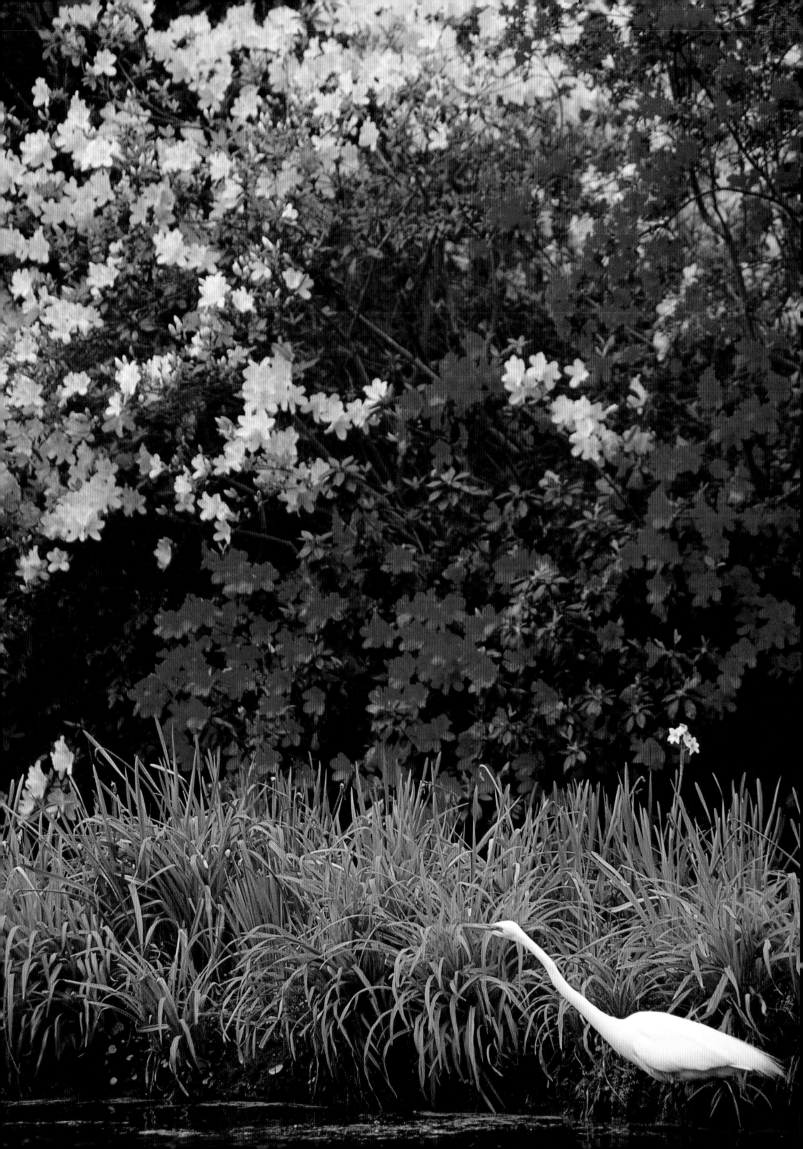

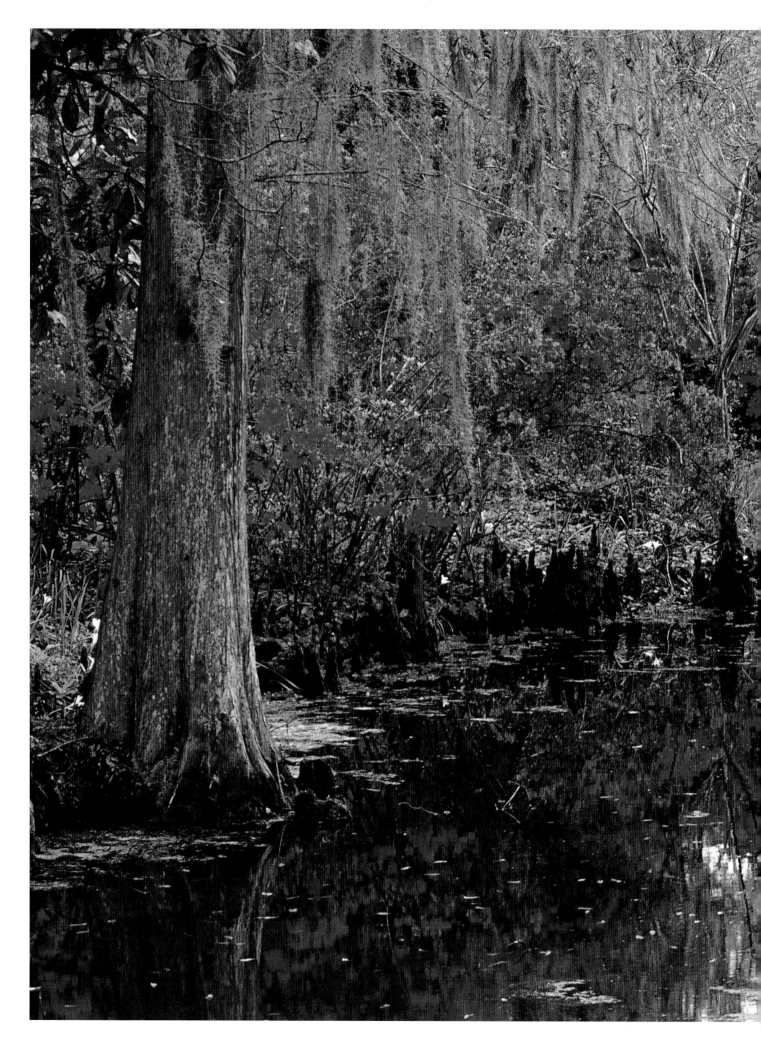

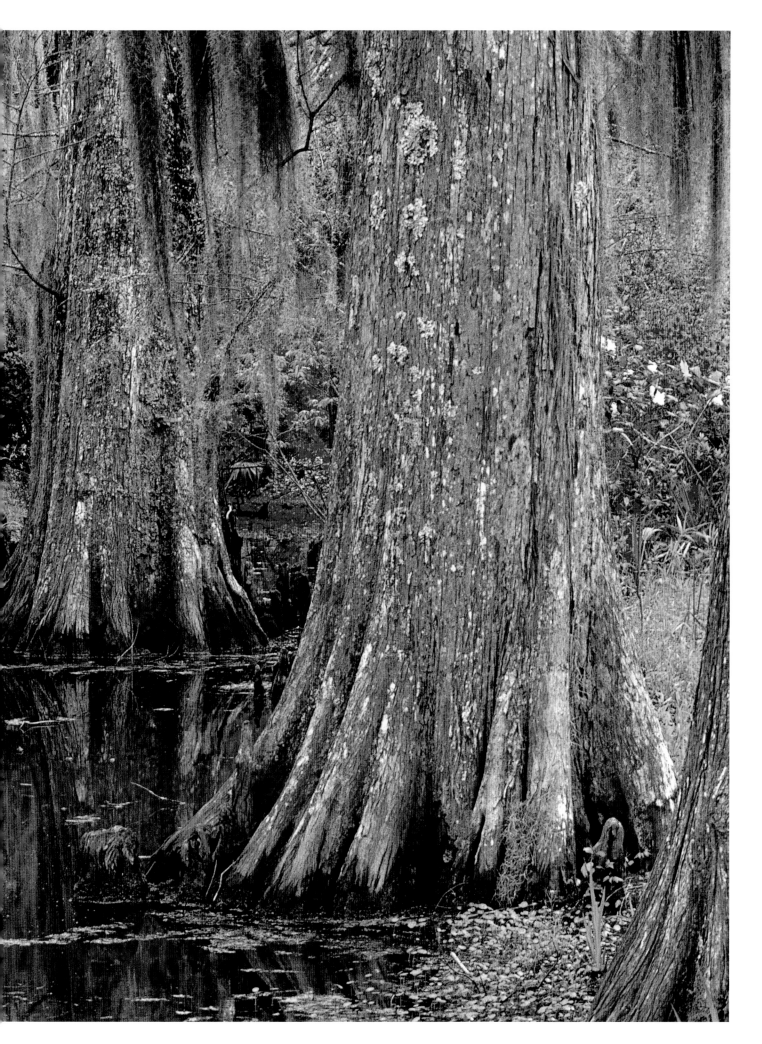

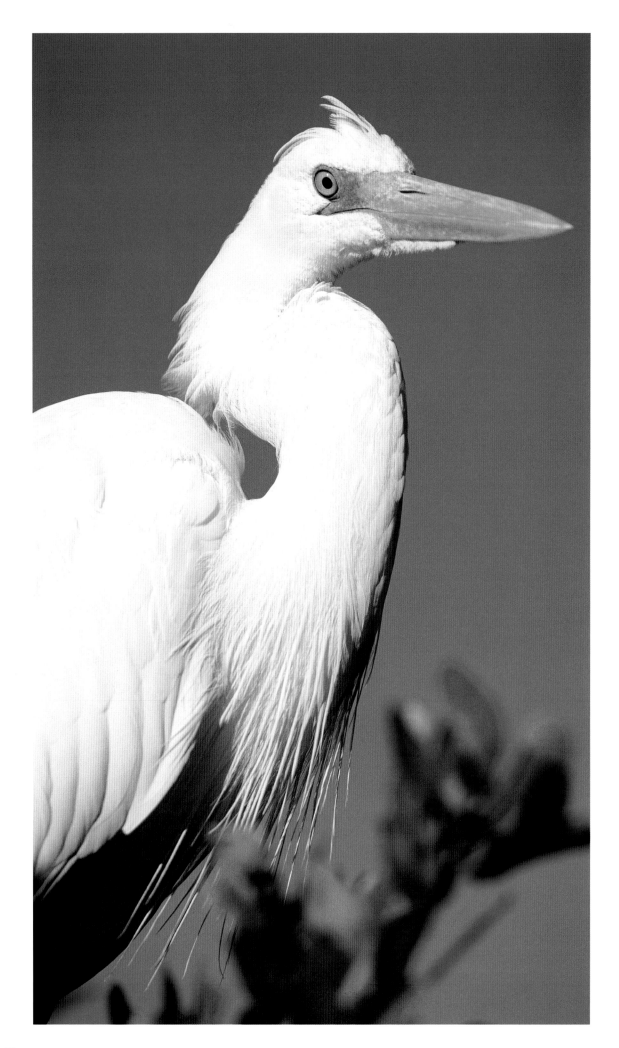

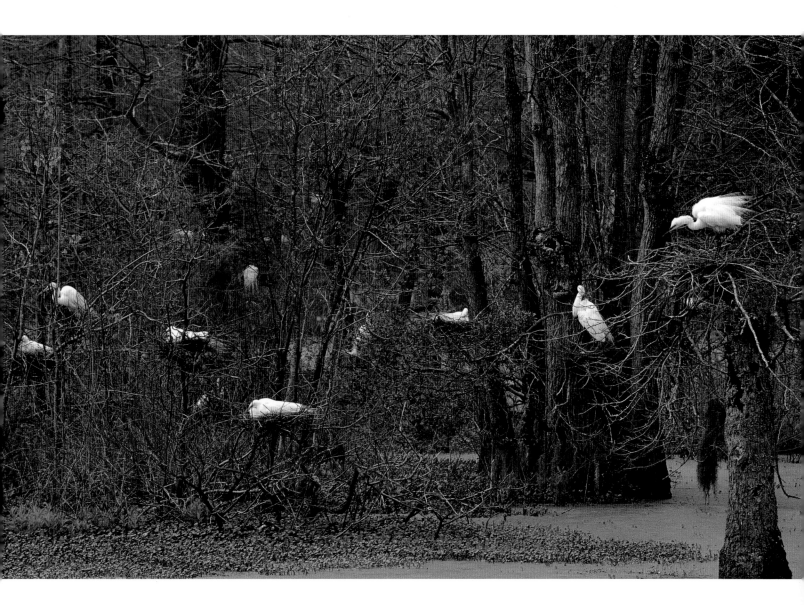

(from page 44) and expensive retreats and resorts. They are being managed creatively, too. They have become increasingly "green" places, where huge live oaks and native stands of cassina and holly receive protection worthy of a historic structure. The building requirements here are as strict as those downtown. Families on vacation enjoy clustered commercial areas, such as the Bohicket Marina Village on Seabrook, where you can watch fishing charters tie up as the sun goes down. The new ponds, created with the golf courses and gently curving roads, are home to great blue herons, shy birds who escape with broad wings as you approach, or snow-white egrets. The Atlantic beach is still as fresh every morning as it ever was, the surfer's "wash" at Folly just as thrilling.

The worshipful sense of place—and this is no exaggeration—has extended itself to even invented places like the beach resorts. But these days, to enjoy Charleston and its region, it is no longer necessary to worship someone else's version of the past, or an edited view. As Charlestonians have become what might be called curators of their own collection, they have found a way to celebrate their history and culture without cutting its corners, while at the same time letting the qualities that make the region so unique inform its future.

◄ *The egrets' brilliant plumage—as white as a freshly washed pocket handkerchief—makes them easy to spot in rookeries.*

▲ *Egrets share space with herons and wood storks in the low-lying habitat; bald eagles soar overhead.*

► *The Butterfly Lakes and terraced gardens at Middleton Place, the result of remarkable engineering and a decade of slave labor, are the centerpiece of this eighteenth-century plantation.*

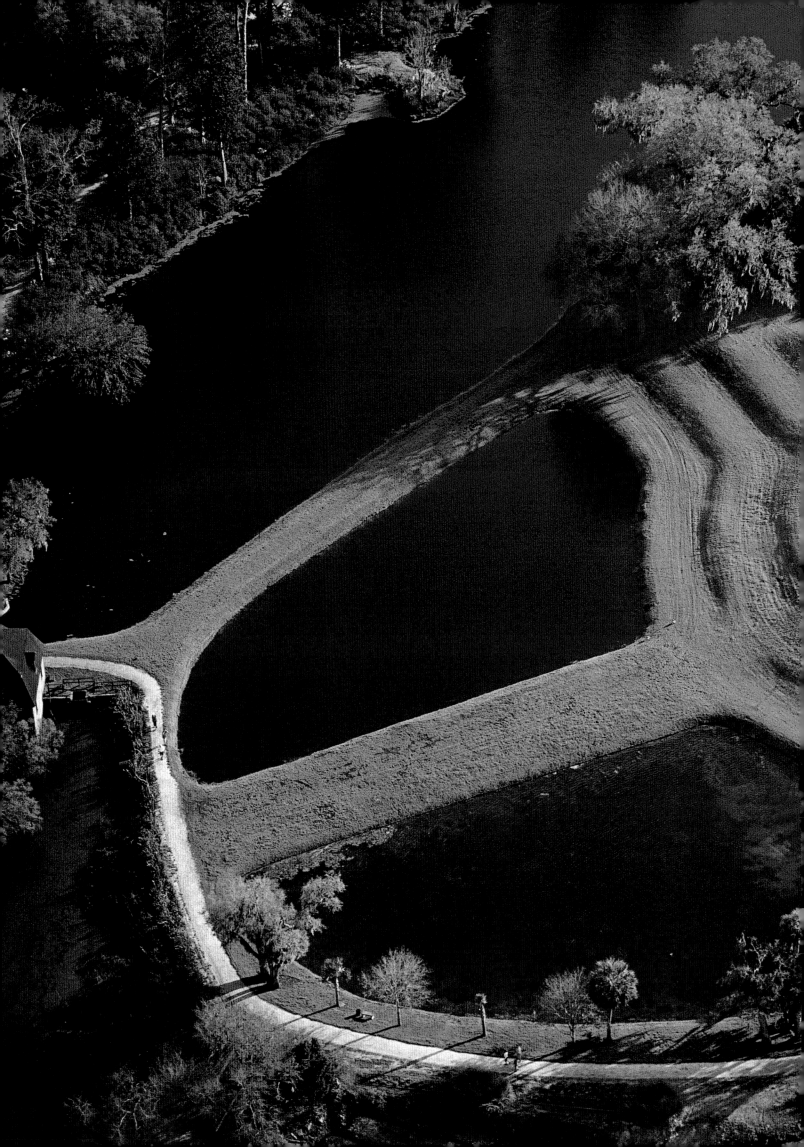

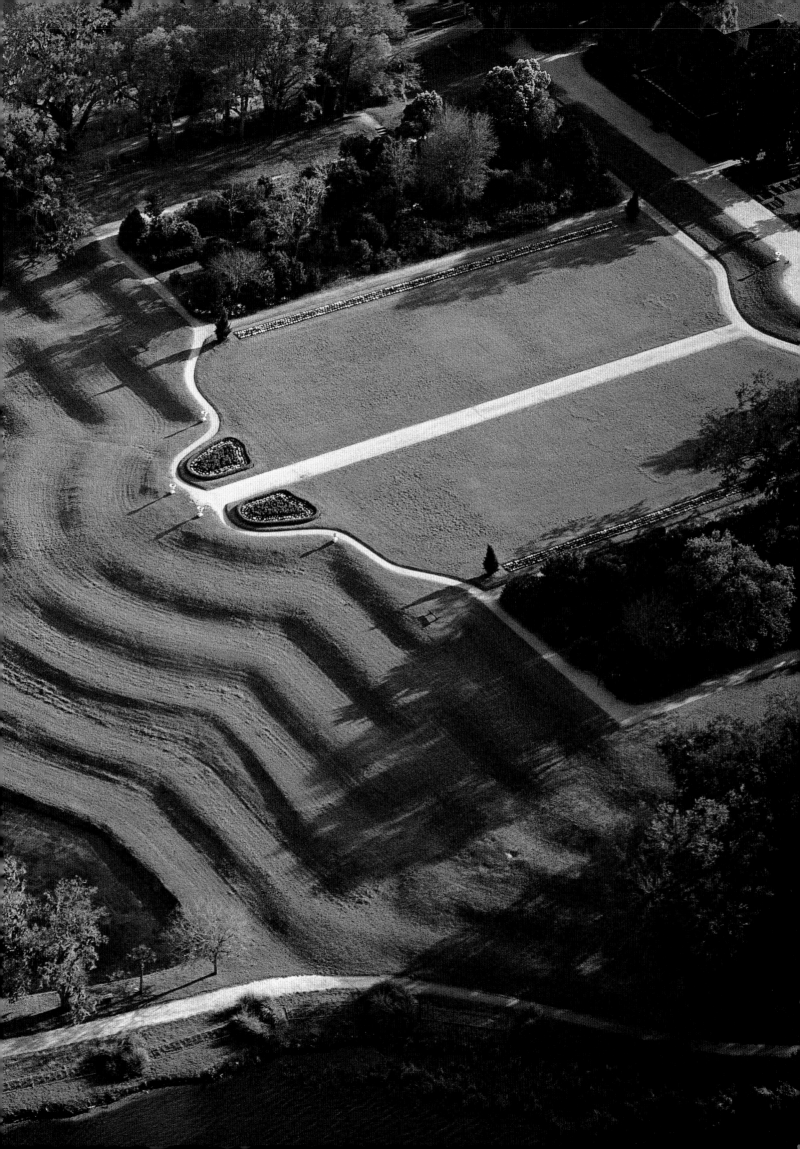

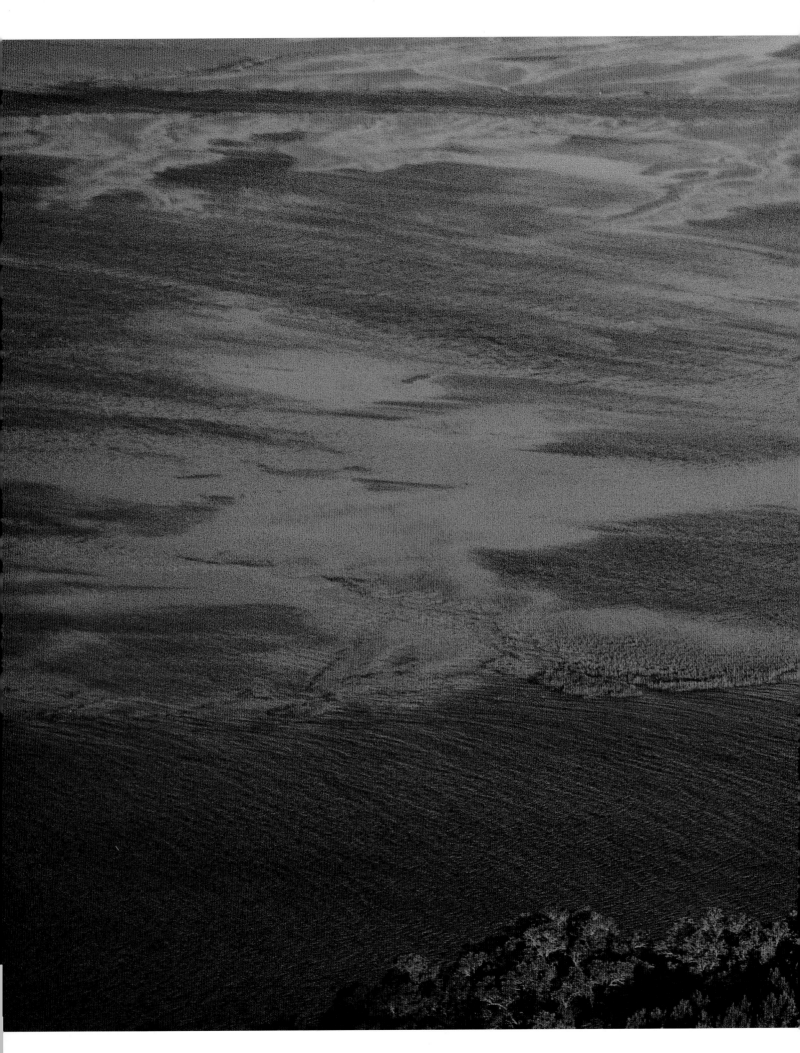

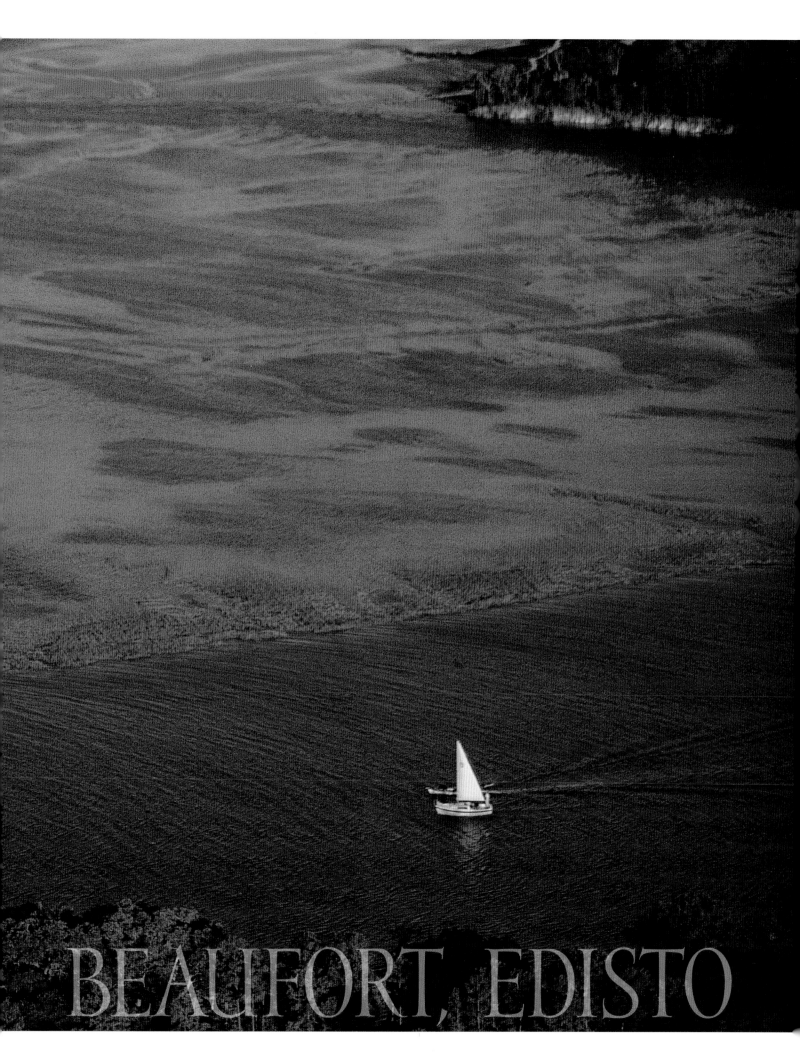

BEAUFORT, EDISTO

BEAUFORT, EDISTO
The Rural Life

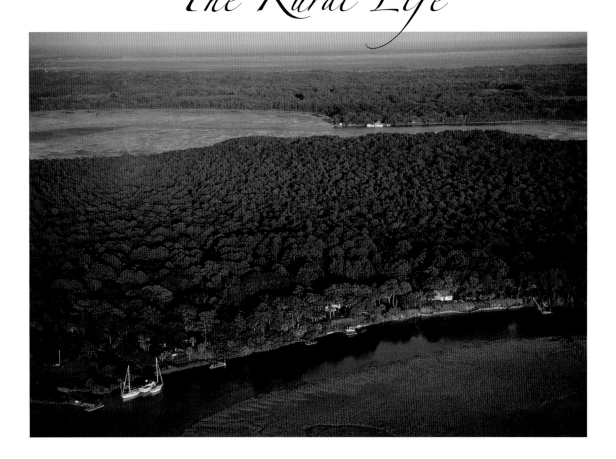

It is easy to see why the cities of the Lowcountry came to look and feel as they do. Neighborhoods accreted like nourished oyster beds, once-new buildings aged and became nostalgic touchstones, and that which was mere habit or inclination eventually found its way to permanent cultural expression. Repetition has a way of conferring identity, of making a city whole. The rural areas and towns between Charleston and Savannah,

❧

◀ *Vast differences in scale and proportion mark the change from the urban to rural Lowcountry, where the predominant view is horizontal.*

▲ *Tidal creeks and rivers define every settlement, both hemming them in and providing a passage away.*

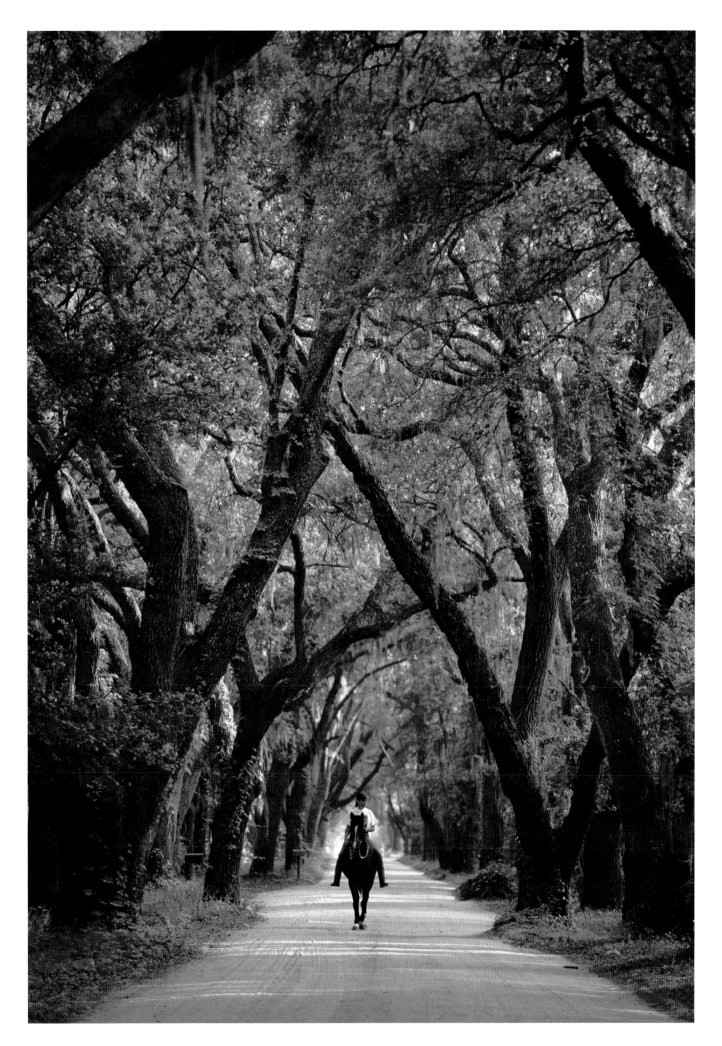

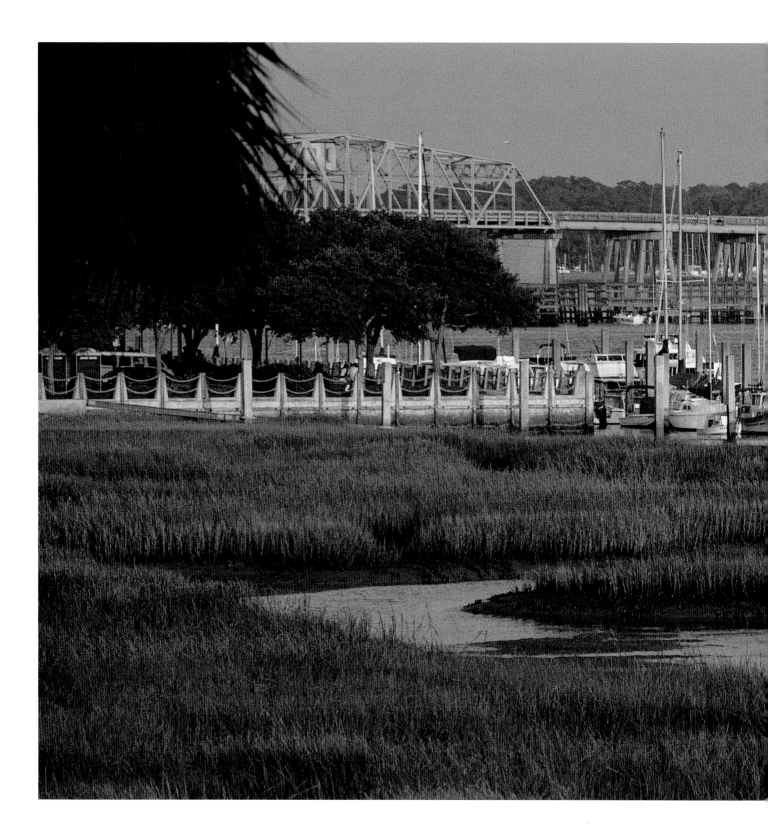

◄ A canopy of live oaks, draped with Spanish moss, a plant that lives on air, keep the sandy road cool and soft.

and the Sea Islands to the east, are no less old or significant, but they give themselves up in a different way. If they lack a congestion of monuments, they offer a clearer picture of the enduring, complex relationship people have to this landscape. It was in the countryside, where abundance and hardship went together, where isolation mandated self-sufficiency, that the plantations thrived, and the unique Gullah culture established itself far from the mainstream of American life.

The rural Lowcountry has long been a patchwork of huge and modest parcels of land, a legacy of the plantation era and Reconstruction when newly

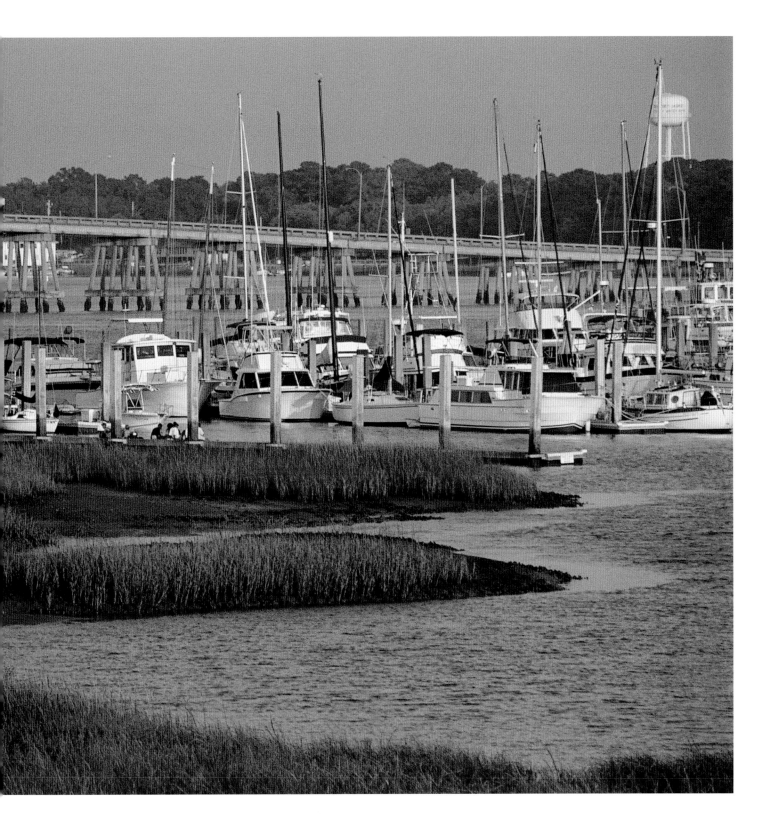

freed slaves acquired property of their own. It has a distinctive look. Just when you find yourself eyeing a vast marsh disappearing into an endless horizon, you will see a small brick house with a dock. Farm fields such as those on Edisto Island or Highway 17 south of Charleston may stretch into the distance, but an abandoned wood frame building, a small church, or a fence tangled with morning glory is not far away. White cattle egrets perch on slow-moving cows; sturdy horses, known as marsh tackies, stand tethered in yards. Communities of small houses and trailers are interspersed among live oaks, and each of these places has a name and a history, usually relating to the

▲ *Beaufort, called one of America's wealthiest small towns in the nineteenth century, sits on a bluff overlooking the Intracoastal Waterway.*

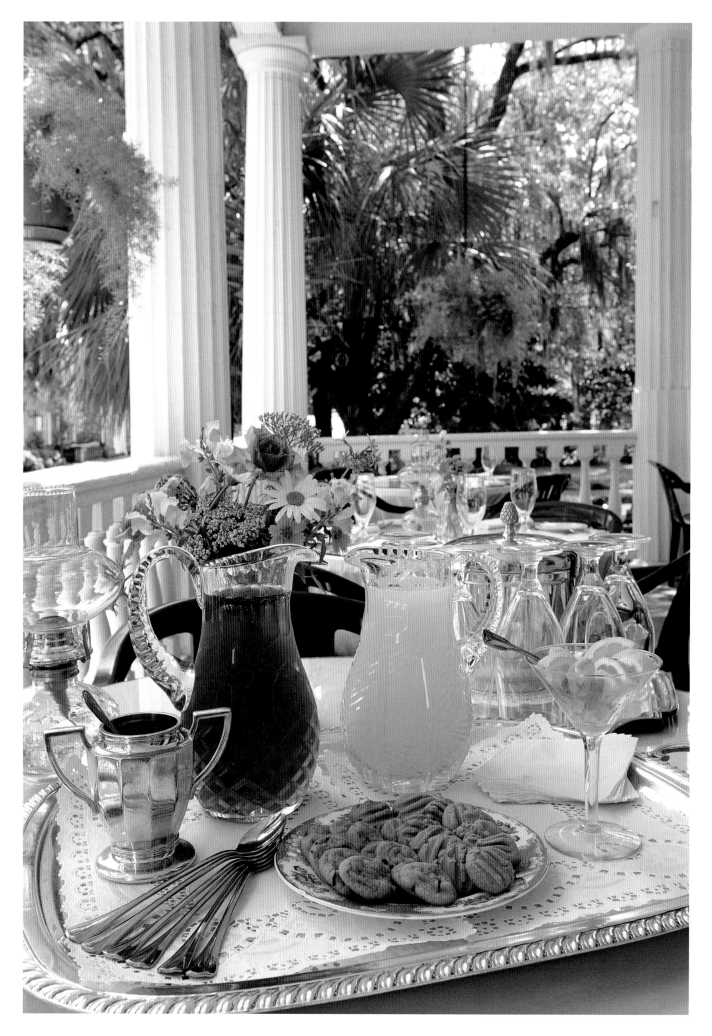

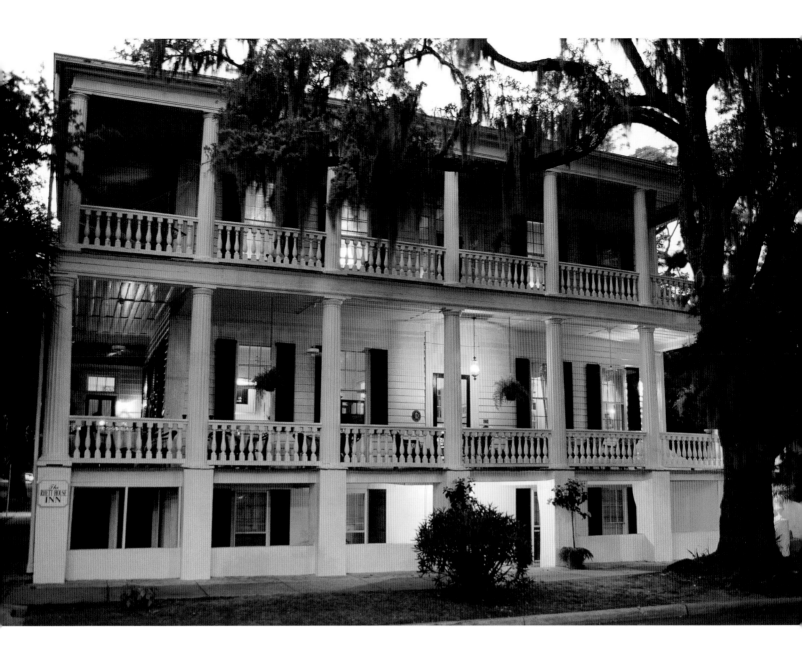

plantation of which it was once a part. Few people make a living off the land, but the land is part of their life, especially for older folks who, every spring tame the brush arbors, mind smoldering piles of twigs and leaves, and prop up the plank benches, nailed between pairs of trees, to make them ready for family reunions in July. They fill their freezers with creek shrimp for company to enjoy.

Edisto and St. Helena Island are the centers of this world. They are Sea Islands set apart from the mainland by rivers, marshes, and sensibility. Although they are less remote than they once were, and gated communities or beach resorts have expanded in their midst, the heritage of African-American life remains strong. It may be visible or invisible to outsiders. Despite years of study by academics across several disciplines, Gullah expression has resisted a single interpretation. In its broadest sense, Gullah describes the culture and language of descendants of slaves brought to the Lowcountry. It is an old culture for America: the first African slave came to Carolina shortly after Shakespeare died. For more than three hundred years, the Gullah culture has maintained its integrity and means of expression, largely in *(to page 65)*

☙

◀ *Elegant refreshments served on the piazza of the Rhett House Inn provide guests with a taste of Southern luxury and leisure.*

▲ *Many of Beaufort's antebellum homes were built on raised basements to "catch the breeze," a style modeled on Barbados architecture.*

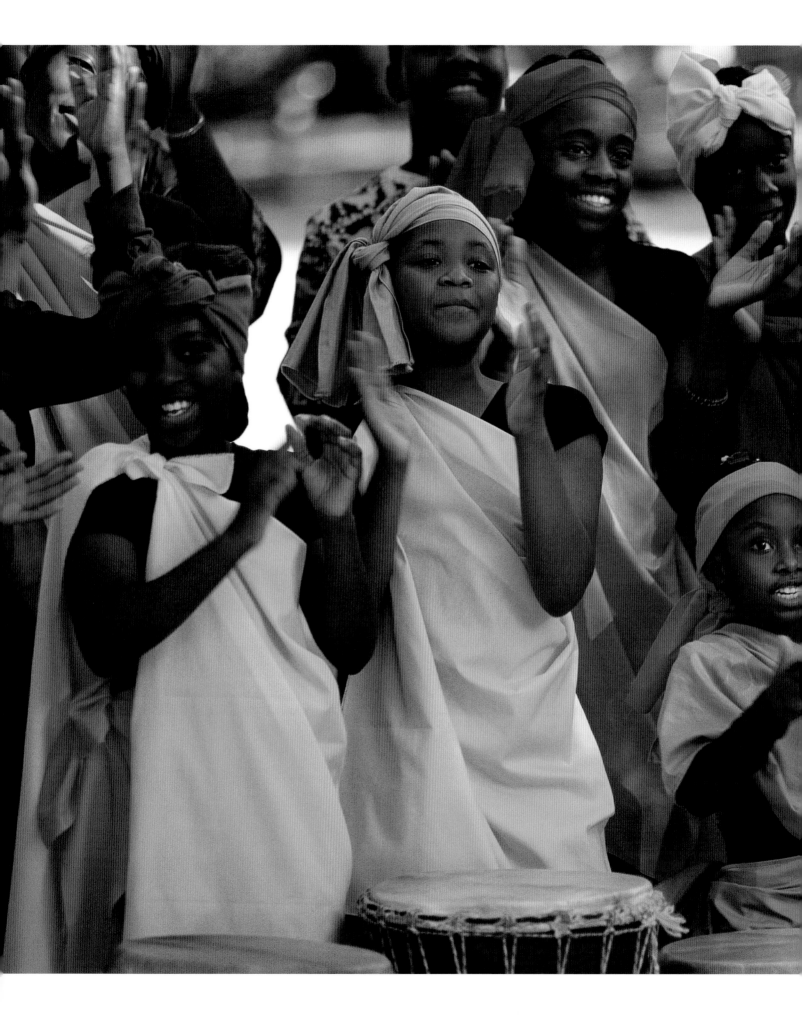

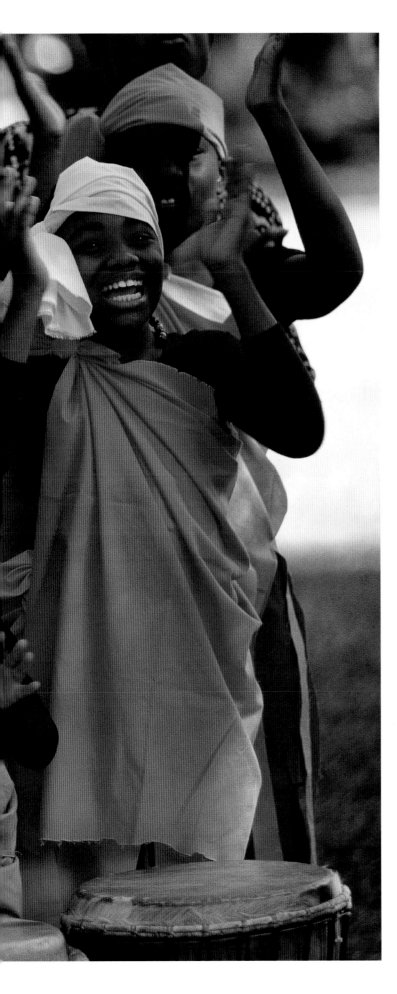

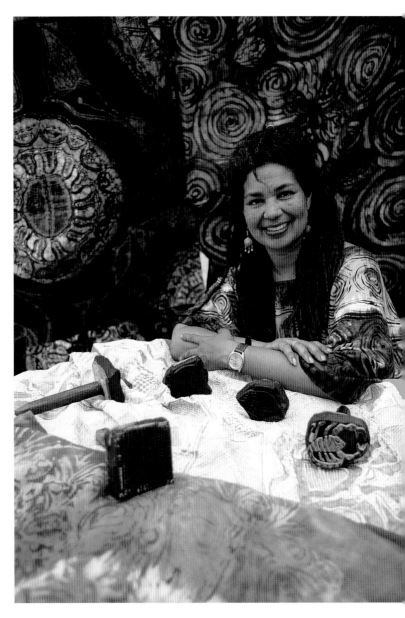

◄ *Every November, Penn Center celebrates its heritage and highlights the cultural connections between descendants of slaves and their African forebears.*

▲ *Artist Arianne King Comer is inspired by West African design traditions, including batik and dye made from locally grown indigo plants.*

► *The ruins of Old Sheldon Church, burned in the Revolution and the Civil War, stand as a ghostly reminder of a proud, isolated community of planters. An annual service is held after Easter.*

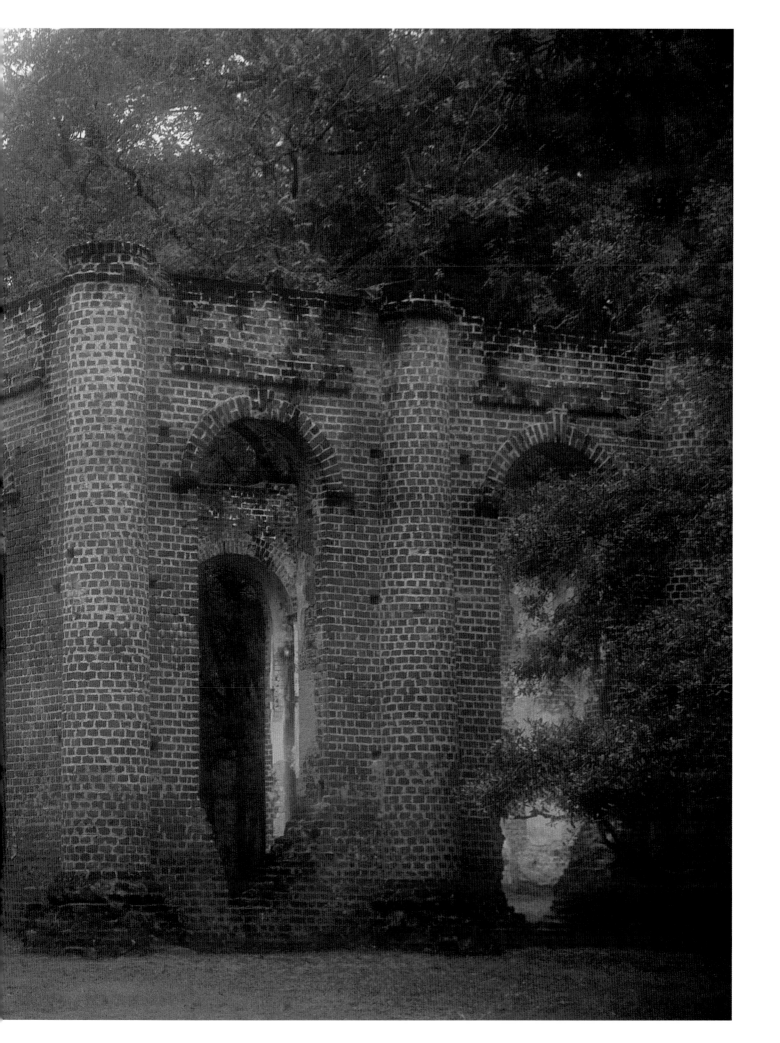

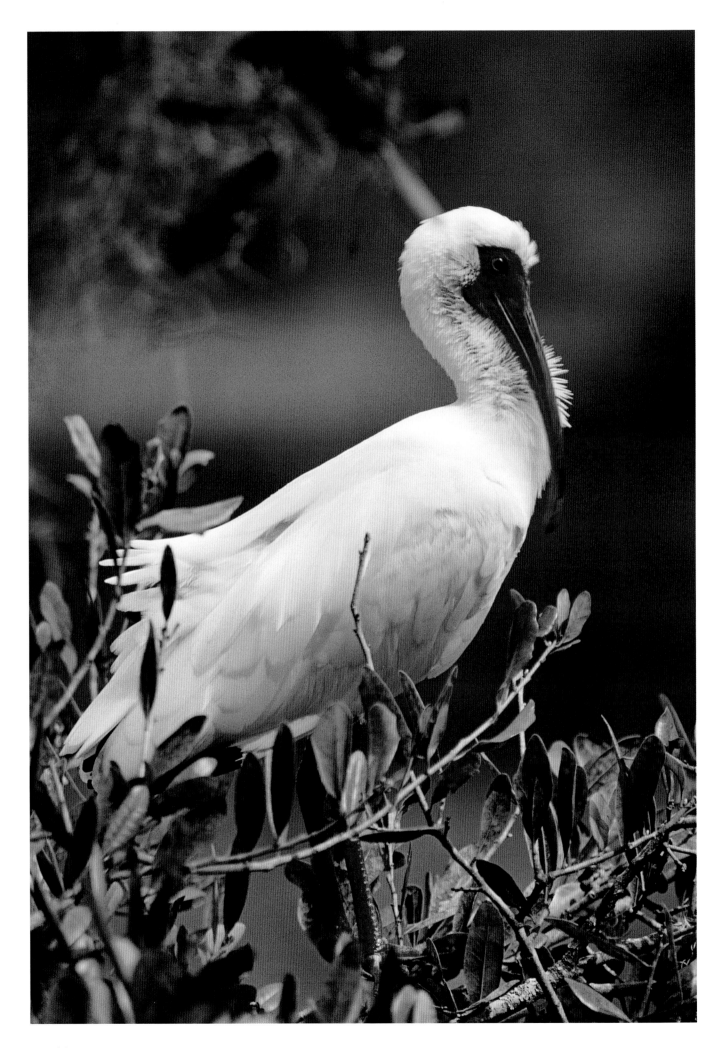

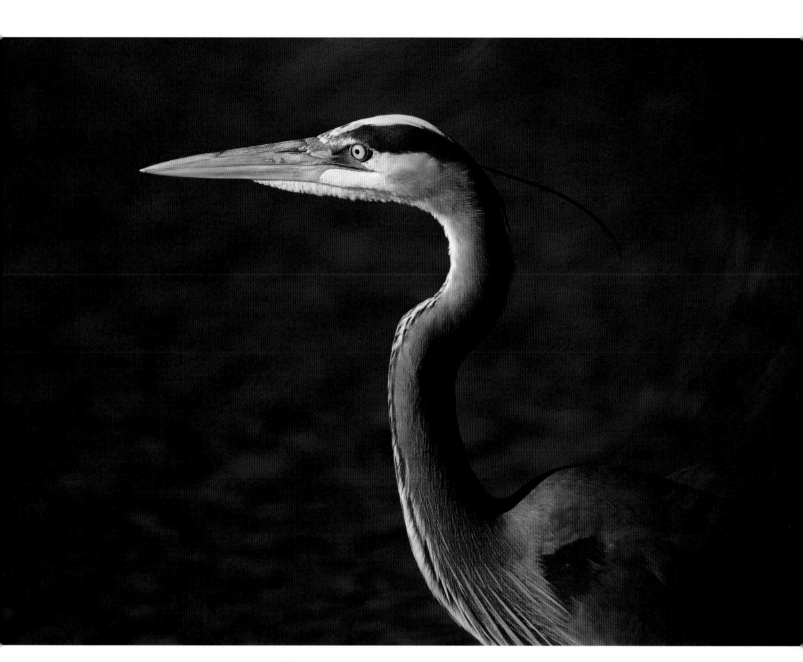

(from page 59) isolation on the Sea Islands. While the arguments about a definition for Gullah will continue—is it a language, a response to generations of enslavement, a survival technique—it is agreed that Gullah is intrinsic to every aspect of the Lowcountry. It has distinctive words and phrases, referenced in the natural world: "first dark" for the precise moment of dusk; "day clean" for sunrise; "busy as a fish" to describe a nonstop two-year-old. The word "too," or the greeting, "All right," are expressed with many varieties of nuance. Ways of cooking, patterns of basket-weaving, the color blue used to paint door and window trim, sentence structure down to the use and place of pronouns, not to mention vocabulary, have pointed to remnant Africanisms that link descendants of slaves to their rice-cultivating forebears on the Windward Coast. Spirituals and stories, with messages of deliverance or clever solutions, and a sense of humor alert to the complicated relationship between the races, are defining elements.

 Edisto, almost every inch under cultivation by 1810, was probably paradise for the first families of Sea Island cotton. Their independent, self-contained

◄ *Large birds are so abundant that early sailors navigated the bars in St. Helena Sound by spotting Egg Bank, where vast flocks rose at once like clouds of smoke.*

▲ *The shy, great blue heron, whose wingspan can reach six feet, is a statuesque presence in the marsh.*

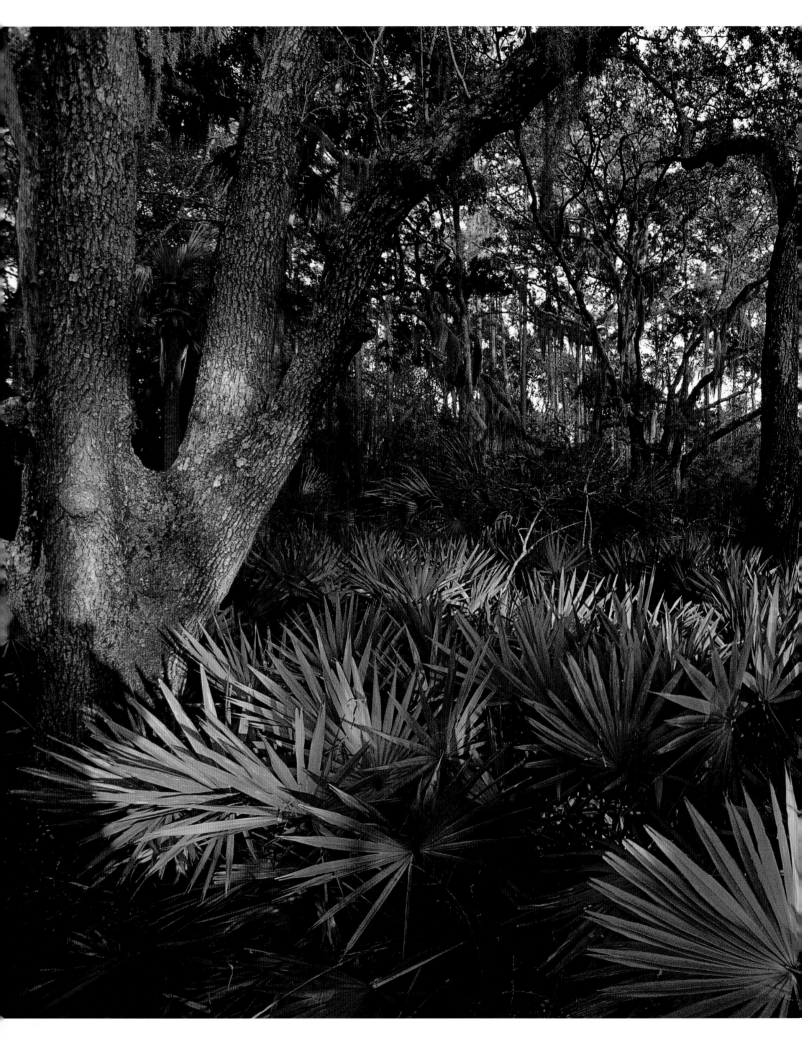

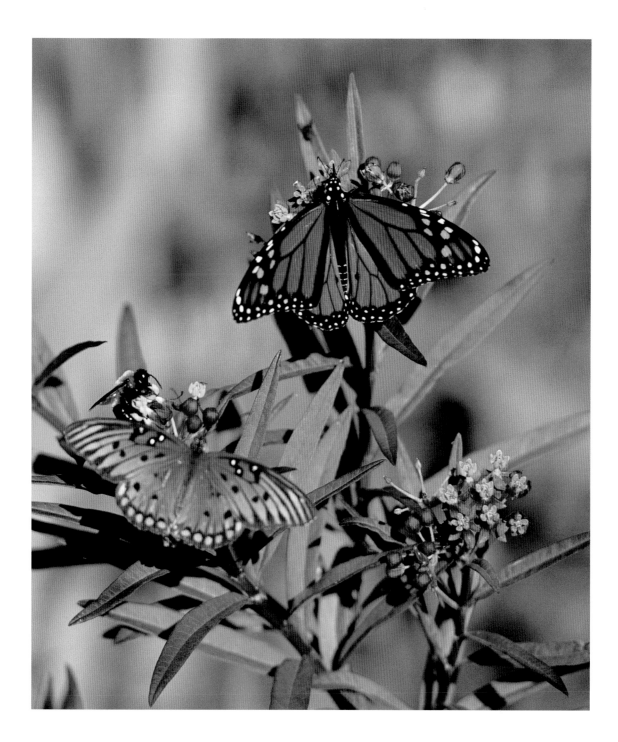

society perpetuated itself through marriage and business ties; their Federal-style houses overlooked the breeze-swept tributaries of the North and South Edisto Rivers. (Some of these houses stand today, but they are not open to the public.) At the time of Secession, an Edisto leader famously announced that, "if South Carolina does not secede from the Union, Edisto Island will!" If it needed Charleston for its cotton factors, lawyers, and outgoing schooners, it did not need it for much else. The Presbyterian Church (c. 1830) and the Old Baptist Church (c. 1818) are reminders of that time, where holiness extends to the manicured churchyards. A small museum tells the larger story, which includes Native Americans, indigo planting before the American Revolution, the Northern teachers who came as missionaries during the Civil War, and the way former slaves worked "shares" of land after the war and created their communities.

◄ *Saw palmetto and thickets of holly, scrub oak, redbud, and wax myrtle make the coastal maritime forest a tangled, wild place.*

▲ *A diverse habitat and temperate climate attract thousands of migrating birds and butterflies in the late fall and winter.*

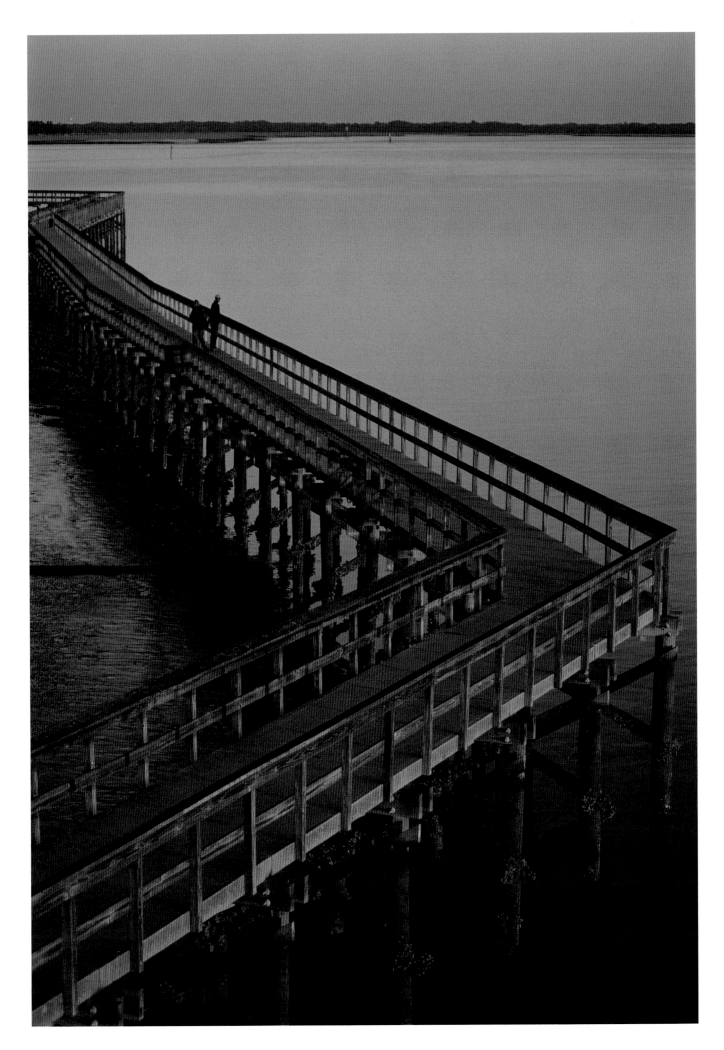

Edisto Beach is a classic in its own way, but redolent of the mid-twentieth century when the beach houses were modest if not homely, and the whole vacation idea was to get sunburned, ride your bike down a dead-straight road, go to the store for bait and candy, hang out at the oceanfront Pavilion, and play cards. Edisto Beach was not just another place on the map; it was another place—next to a place from another era. A state park with campsites and cabins was established in the 1930s, and the beach is popular today, still well-known by collectors for the abundance of its fossils. It has not suffered the serious erosion of Hunting Island State Park, near St. Helena, where tree stumps and palmetto logs line the beach, giving it a wild look.

Here as elsewhere in the rural Lowcountry, there is fear that development will overwhelm and change the very qualities that make it special. One place it will certainly not is in the ACE Basin, a crescent-shaped stretch of land and water that runs roughly from the tip of Edisto Beach to the tip of St. Helena Island and miles inland, along the Ashepoo, Combahee, and Edisto Rivers. This tract of about 350,000 acres is one of the largest undeveloped estuarine sanctuaries on the East Coast, home to at least seventeen endangered species and uncounted numbers of migratory birds and waterfowl, fish, and wildlife. It includes several islands that are still the sites of fishing camps where Lowcountry men return to be boys again. From departure points at Edisto Beach, Green Pond, Bear Island, and Beaufort, to name a few, people hunt and fish, take nature tours, hike, or launch their boats or kayaks. It is as much a jewel of preservation efforts as Charleston.

St. Helena Sound—the part of the ACE Basin that meets the Atlantic— lies between Edisto and St. Helena Island, a trip of about nine miles by water, about ninety miles around the crescent by car. The islands share many similarities, including a slave population that was ten times the white population, and the sense of isolation, but St. Helena's larger size, strategic location relative to Beaufort about eight miles away, and its particular history set it apart and have made it different to this day. The change came in early November 1861, when Federal troops took control of the area, forcing the white residents to flee. Left behind were some ten thousand slaves. Over the following months, as the military established headquarters in Beaufort's abandoned mansions, Northern abolitionist groups enlisted individuals to educate the former slaves. From Philadelphia came Laura Towne and Ellen Murray, and from their efforts grew the Penn School on St. Helena, one of the country's first schools for newly freed slaves. Known today as Penn Center, it remains an important island institution, dedicated to history, education, and community-building, as well as cultural expression. There are permanent exhibits at the York W. Bailey Museum and monthly performances of spiritu-als and choir music in Frissell Hall from September to May. Heritage Days, in November, draws thousands of visitors hoping to see for themselves a link with an African past. Next door to Penn is the antebellum Brick Baptist Church, and further along the road are the evocative ruins of a Chapel of Ease, built in the 1740s to serve the spiritual needs of planters far from town. The construction material included brick and tabby, a local product made of sand, lime, and oyster shell mixed up as a kind of slurry and poured within a

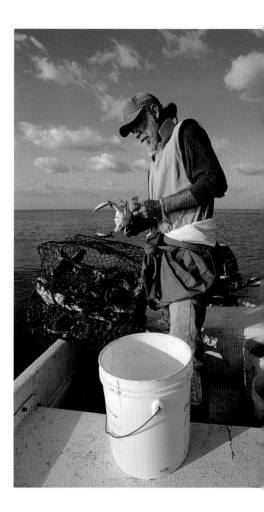

❧

◄ *At low tide on the Port Royal boardwalk, strollers can glimpse the channel to see shallow pools dense with fish and schools of dolphins swimming in the river.*

▲ *Crabbers like Capt. Ron Elliott from Edisto set and harvest traps from small boats with shallow drafts.*

► *Shrimp boats at twilight at Port Royal— the end of a day that starts well before dawn.*

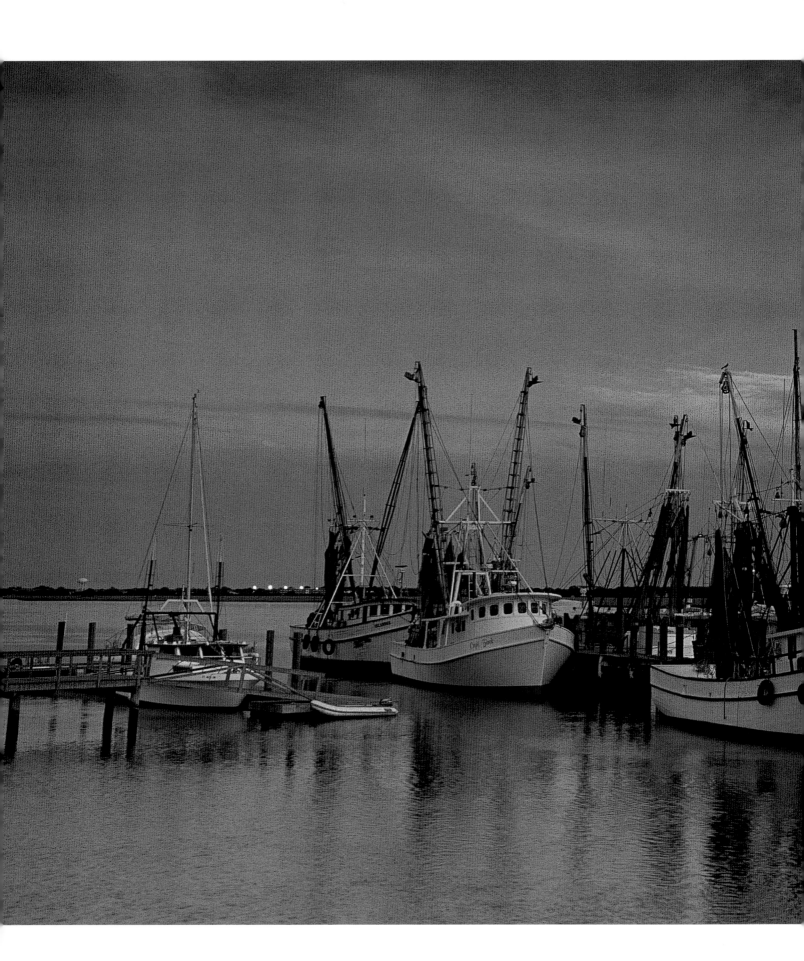

frame to harden. At the intersection with the main island highway, once called "Corner Plantation," a variety of stores and restaurants feature folk art and regional cooking. A half-dozen plantation houses still stand, many visible from the road or the water, but they are not generally open to the public.

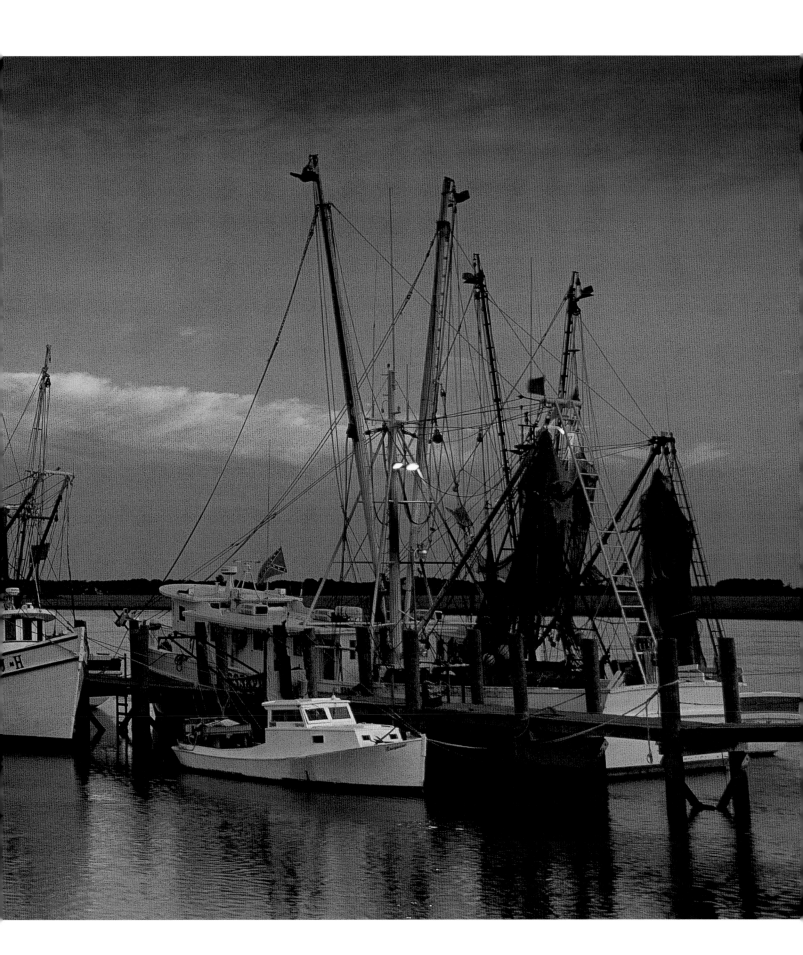

Where St. Helena's landmarks are dispersed—cemeteries framed by palmetto and rimmed with nandina, praise houses with rickety stairs scuffed by scrub oak and surrounded by phlox—Beaufort's are concentrated. By 1815, it was quite a substantial town and as cotton profits increased, so did its sense

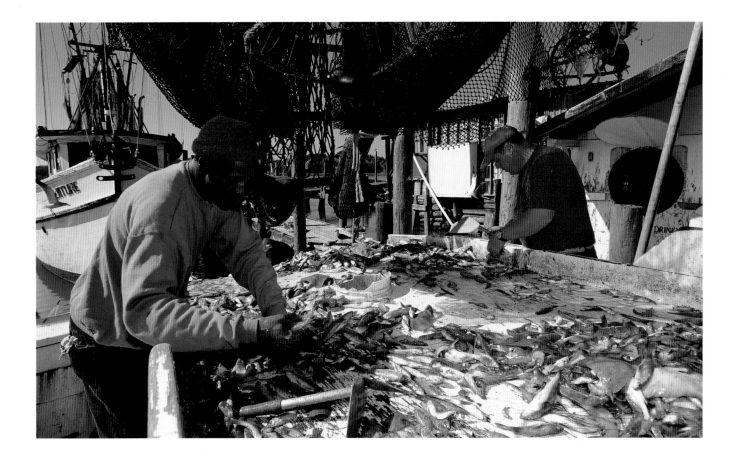

▲ *By mid-afternoon, the catch is sorted and priced according to the count of head per pound and iced for sale at the dock.*

▶ *Nets are rigged on a pair of masts, which are lowered for trolling and raised to bring the haul on deck. From a distance, the shrimp fleet resembles a flock of huge, angular birds skimming the sound.*

▶▶ *Marines have been based in Beaufort County for more than a century—today at Parris Island and the Air Station.*

of confidence and stability. In an area known as The Point and along Bay Street, facing the Beaufort River, which laps at the bluff, there are dozens of antebellum homes, some brick, some clapboard, some with huge stone columns, many with Palladian windows and ornate Adam-style decoration. As in Charleston, first floors may be ten feet off the ground, raised in an effort to catch the breeze. This is the land of huge porches, known as piazzas, jib windows built so you can open them and walk through, jasmine-covered fences, and gardens where something is in blossom every month. The John Mark Verdier House Museum (c. 1790), the home of a wealthy merchant, is still in the thick of the action as it was when it was built, although now its neighbors are art galleries, fine clothing stores, and fancy restaurants.

And it's not just homes that were built with a sense of style. The warm light that fills St. Helena's Episcopal Church, built from English brick in 1724, streams through the wooded churchyard to highlight rows of tapered columns and a wraparound upstairs balcony. Those who worshipped at the Baptist Church in 1844 must have had their heads turned by the massive Greek Revival plasterwork and carved cornices. Even the ruins are beautiful. Out of town, toward Yemassee, sits Old Sheldon Church, burned twice in its long life, first by the British in 1779 and then by the Union Army in 1865. Arches, sill slabs, and brick columns are about all that remain—but there are yearly services here after Easter, as there ever were and will likely always be.

This sense of permanence extends to the other institution the area is well known for. It too is old, proud, soaked in tradition. It inspires reverence, and to those who have known it, a return visit imparts a sense of instant familiarity with the past, and sometimes dread. It is, of course, the Marine Corps

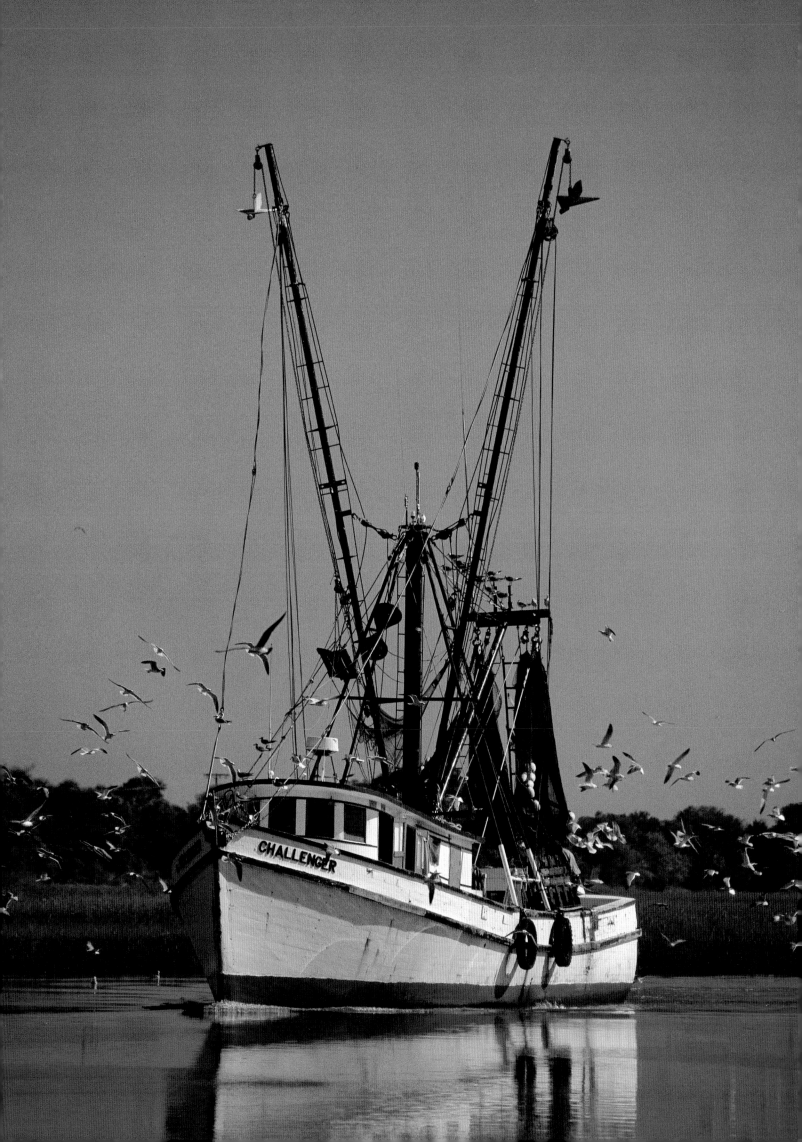

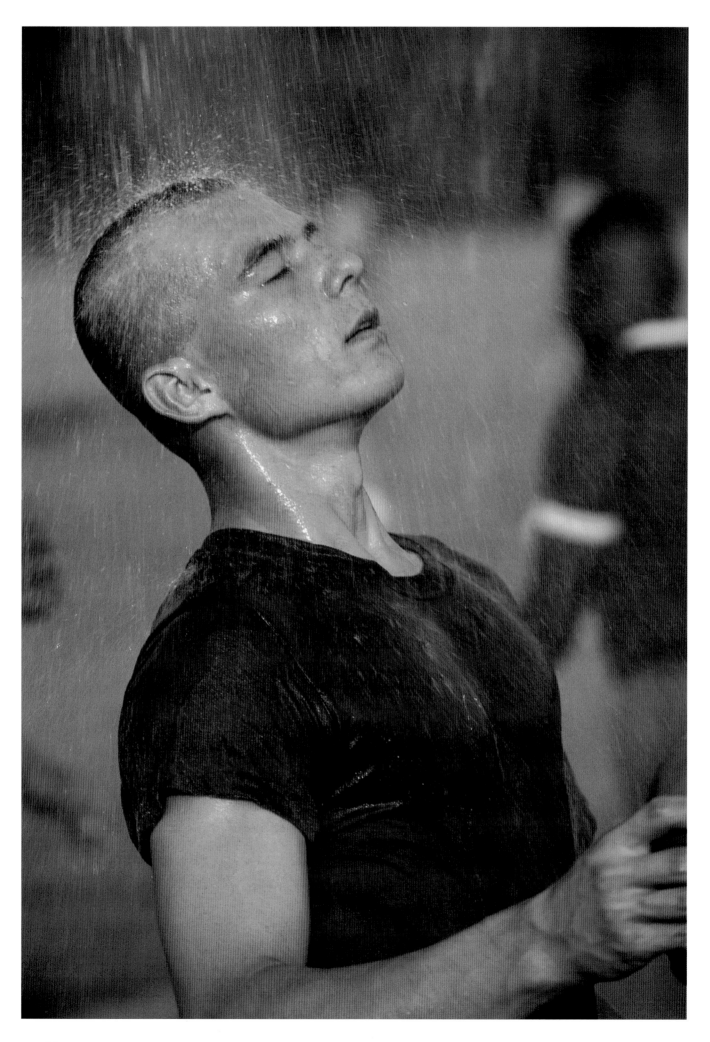

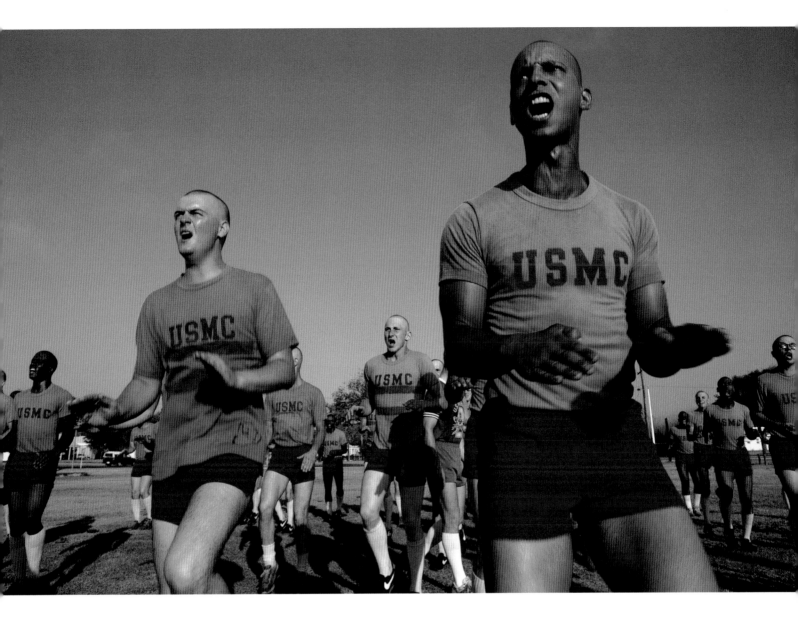

Recruit Depot at Parris Island. It is one thing to imagine the past in an old building, or a landscape, quite another to see a version of yourself in a new batch of recruits—the raw, scared young person you may have been. Even for an outsider, it is a moving experience. In addition to a fine museum, recent archaeological excavations have expanded knowledge about French, Spanish, and Native American habitation, recalling the time when the area was being savagely fought over.

As Beaufort has prospered, gone are the days when a store sold one cigarette or families painted their houses one side at a time, or Bay Street at its far end turned into a shell road and few people with cars complained. Now traffic backs up considerably when the bridge to the islands swings open to let boat traffic pass on the Intracoastal Waterway. As much as the past is venerated in town and the rural areas, not many would return to 1925 when there was no bridge at all and definitely not enough traffic for a small town trying to make its way out of poverty. Instead Beaufort is trying to hold on to its small-town feel, just as residents in the rural areas want to keep their Gullah heritage intact and make it meaningful to a new generation. The question is how to hold on to the past but not become a version of it, of how to remain vivid.

▲ *The training of male and female Marines at Parris Island is tough and legendary. Recruit graduations are open to the public, as is the Museum.*

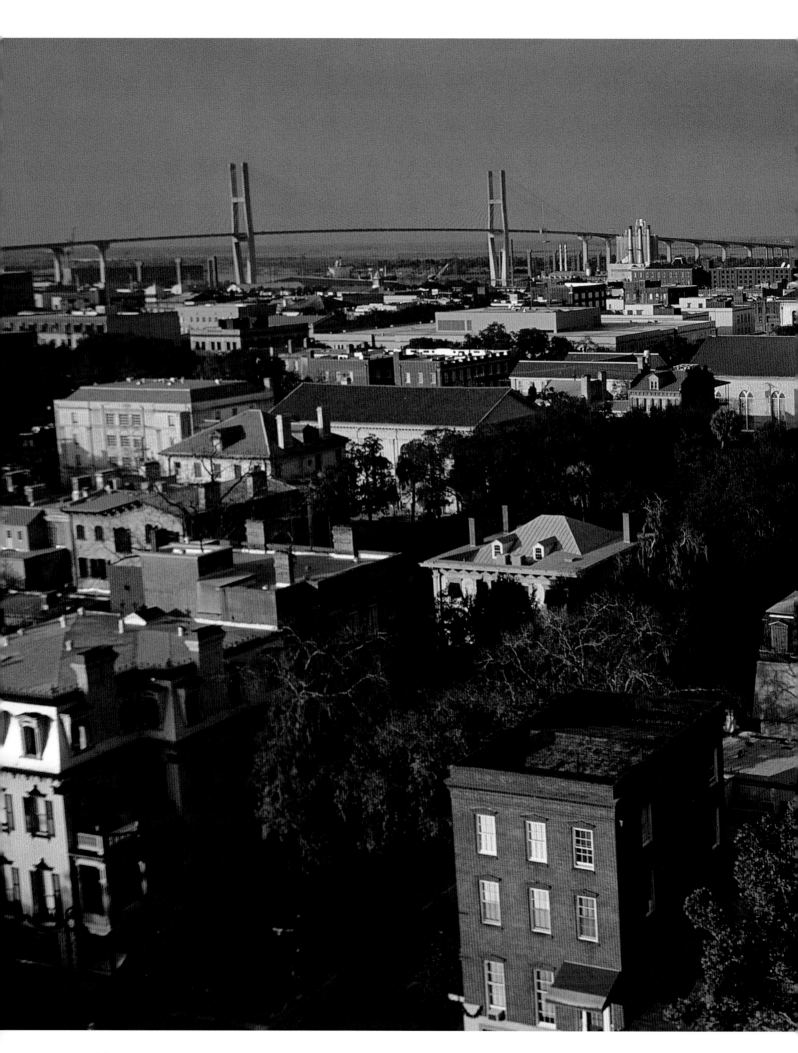

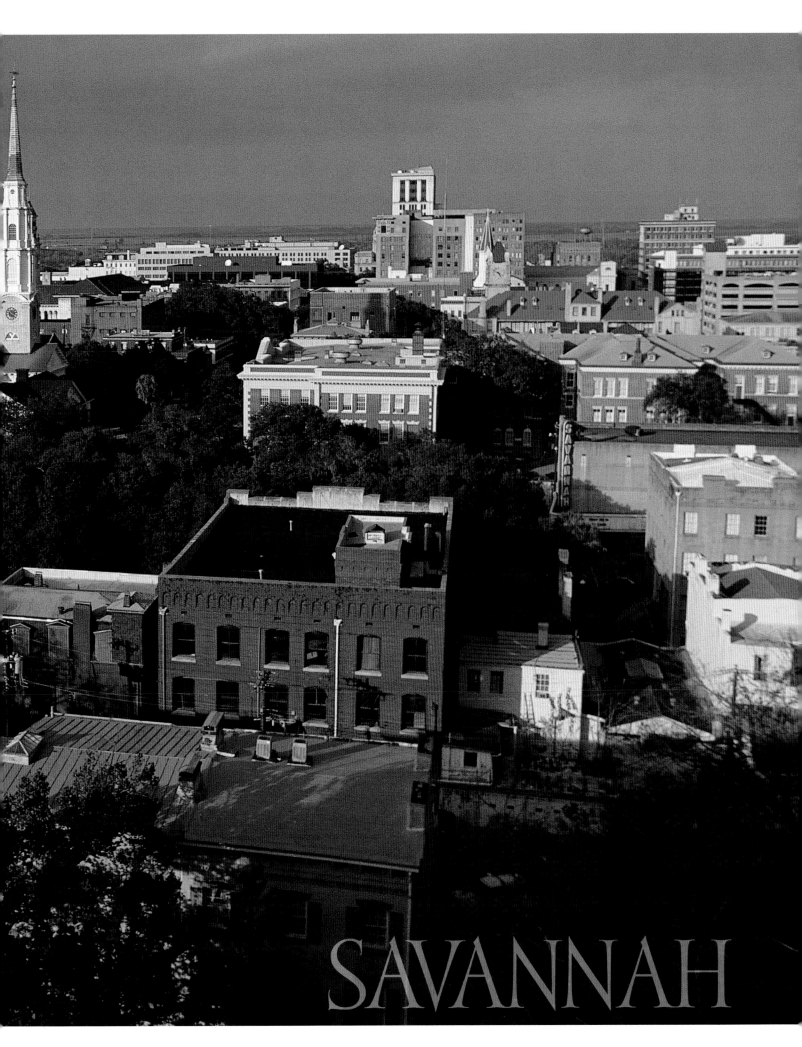

SAVANNAH

SAVANNAH

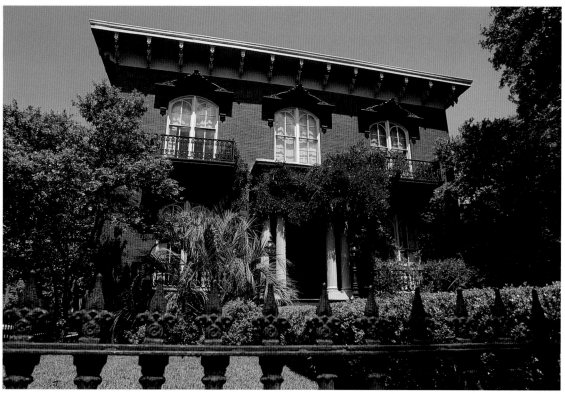

It is a well-known fact that every Southern city harbors its eccentrics. Sometimes they are viewed as truth-tellers, wise but out of synch by a century with everyone else. Sometimes they are simply part of the view: if they aren't where everyone expects them to be, growing old in their routine, it might be cause for alarm.

Savannah, Georgia, may have no more eccentrics than other cities below the Mason-Dixon Line, but it seems as if every one of them had his fifteen minutes of fame in John

❧

◄ *Savannah has been a thriving seaport since its founding, but also an occupied city, an exotic backwater, a movie set, and center for the arts.*
▲ *Lush gardens rimmed with iron fences frame Mercer House on Monterey Square, featured in* Midnight in the Garden of Good and Evil.

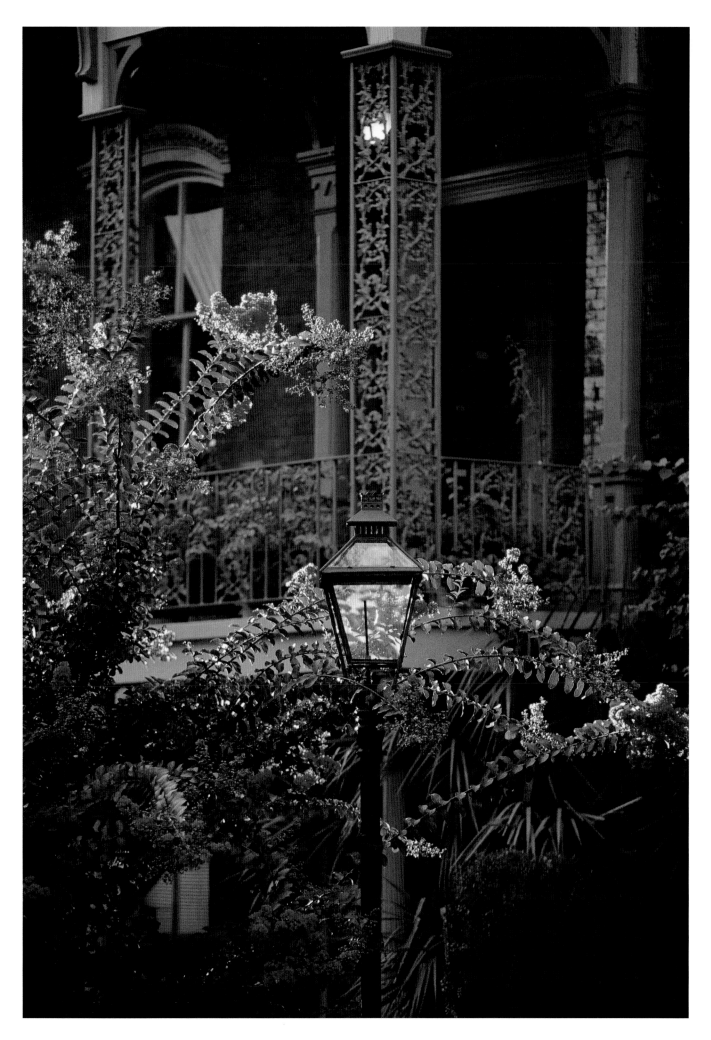

Berendt's panoramic best-seller, *Midnight in the Garden of Good and Evil*. The book recounted a true case—a sensational murder and subsequent trials—but one of its many strengths was to describe dozens of characters who called Savannah home and to make a character out of the city itself.

The fact is, Savannah loved the book—which is called "The Book" there. The attention it brought resulted in more visitors, themed tours and merchandise, gossip for every ear, and photo opportunities. Whether the city fathers liked it or not, it brought a static historic city alive, more than decades of house tours ever did. The way the book was embraced says a lot about Savannah's view of itself as an irreverent, live-and-let-live kind of place. Residents are more likely to eat lunch at downscale Clary's on Abercorn Street, where they talk across the next table and pay at the register, than in any of the newer, fancier places. Going to the beach means filling a cooler first. Johnny Mercer was a native son. It's more his kind of place than Cole Porter's. General William Tecumseh Sherman was so taken with Savannah's beauty and its sociability that, rather than burn it in 1864, he presented it as a Christmas gift to President Lincoln in a famous telegram. Then, it is said, he promptly went to a ball. His magnificent headquarters, the Gothic-Revival Green-Meldrim House on Madison Square, gives a clue to his motivation.

The irony is Savannah's spirit happens to flourish in a meticulously planned city of manicured squares that was laid out in the 1730s and is not only a unique American urban environment, but a National Historic Civil Engineering Landmark as well. Maybe it's easier to be an eccentric when you're surrounded by order.

Savannah was founded by a group of Englishmen called the Trustees, idealists motivated to create a community populated by hardworking, impoverished people whose passage they paid to the New World. The settlers had to be willing to make a go of it without benefit of slaves, vast land grants, liquor, or a secure market for their proposed exports, principally silk. General James Oglethorpe, their leader, chose a high bluff eighteen miles upriver from the mouth of the Atlantic for his utopia. There, he and Colonel William Bull created a city of twenty squares that backed into the woodland, reserving space for markets, public buildings, homes, and communal gardens. Most of this plan remains intact as today's Savannah.

The founders' idealism continued in fits and starts, as idealism often does, and before thirty years were up, Savannah had come to resemble Charleston, its older and more prosperous neighbor to the north. There were more speculators, more slaves, and a growing sense of security as Native American hostility was fended off and Spanish and French claims fell to the British Crown. Savannah established itself as an important colonial port and hit its stride in the decades immediately preceding the Civil War. Then, as now, it was the point of exit for the abundant natural resources and raw material from the backcountry, as far upriver as Augusta. New Englanders like Isaiah Davenport, who built his Federal-style house in 1820, saw opportunities in the expanding commerce. River Street itself is paved with ballast stones, the material used to stabilize lightly loaded trade ships crossing the Atlantic. These were dumped so the ships could return filled to the gunwales *(to page 87)*

General William Tecumseh Sherman was so taken with Savannah's beauty and its sociability that, rather than burn it in 1864, he presented it as a Christmas gift to President Lincoln in a famous telegram.

❧

◄ The rampant flowering trees of the countryside—Banksia rose, crepe myrtle, palmetto, and trumpet vine—are tamed in the city.

► City Hall was built overlooking the Savannah River in 1905, on a site that has been used for municipal buildings since 1799.

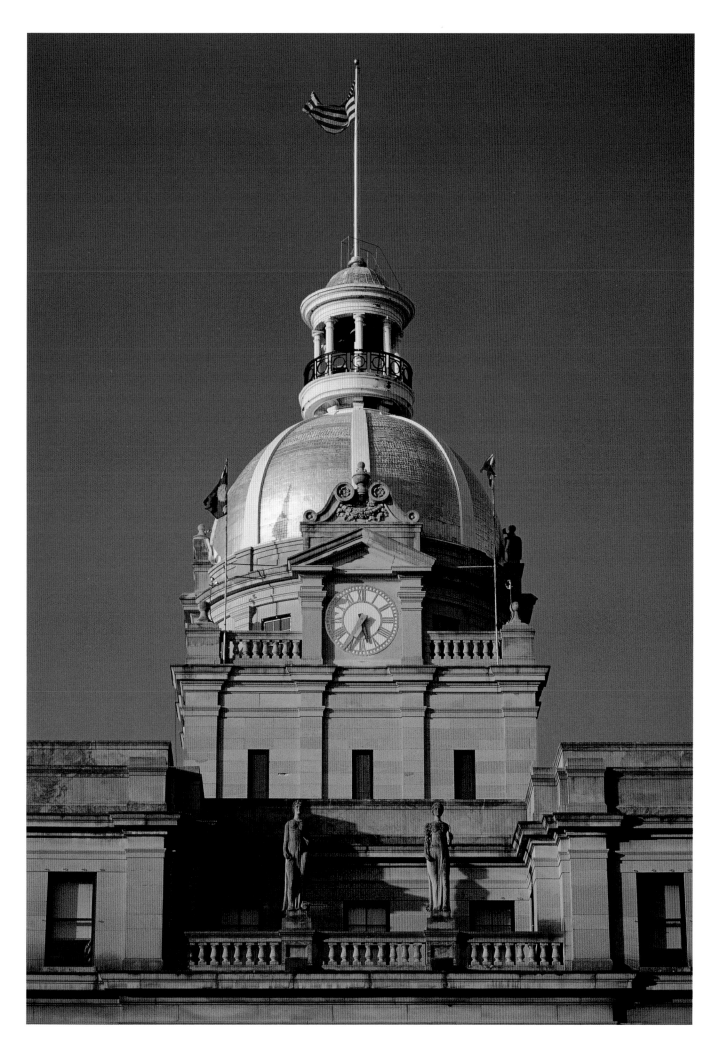

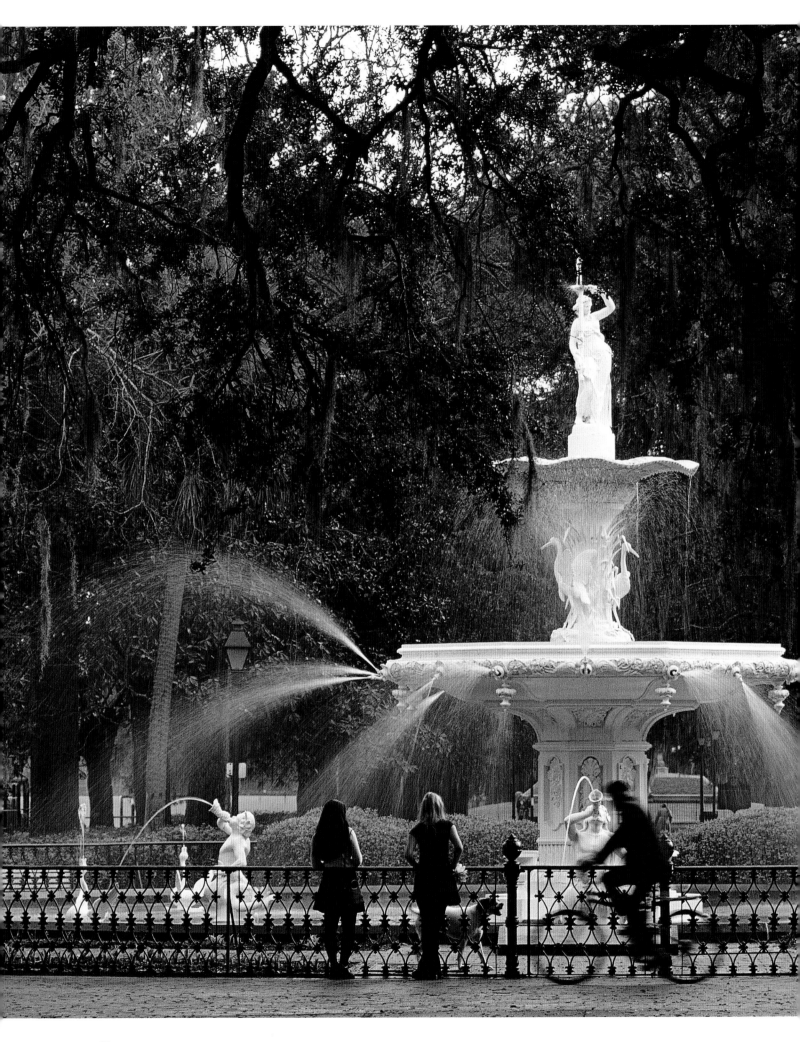

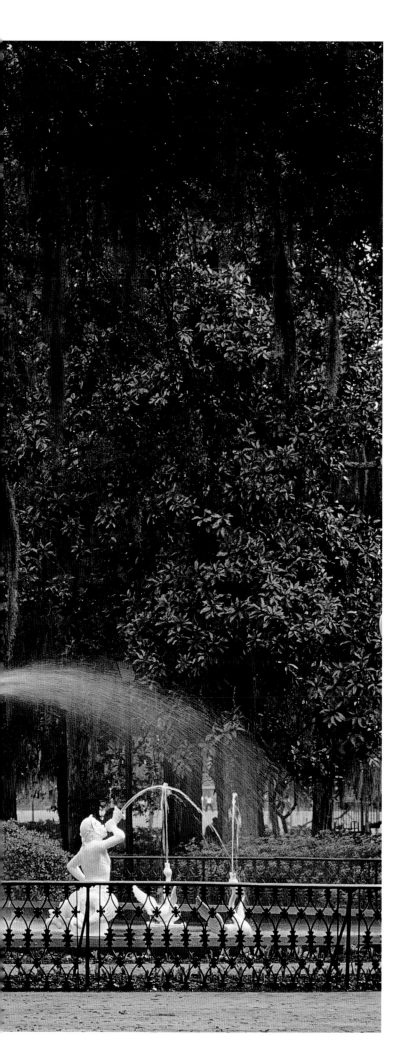

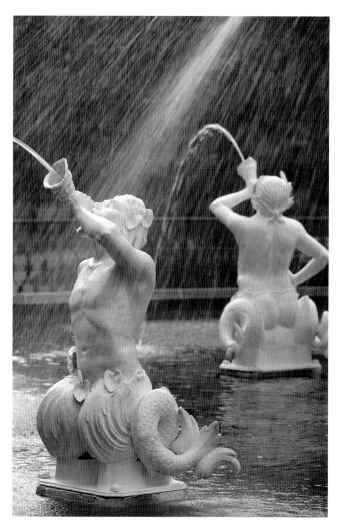

❧

◄ When lit at night, the massive fountain at
Forsyth Park casts its golden glow over the lawn;
by day, it is a refreshing meeting place.
▲ The sounds of water spouting from tritons'
mouths blend with glorious scents from the
Fragrant Garden for the Blind at Forsyth Park.

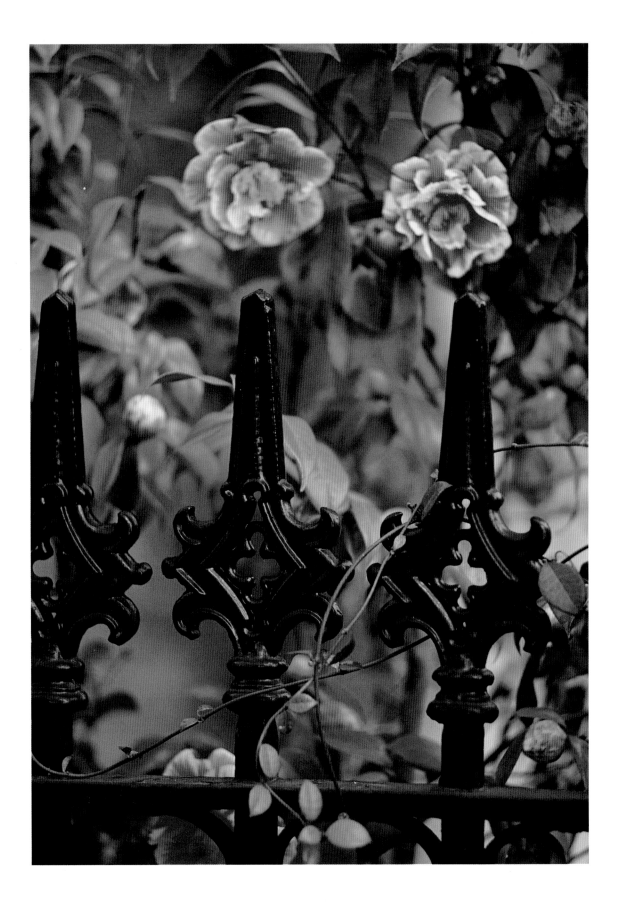

❧

▲ *Compact row houses, grilled gates, recessed doorways, and half-concealed gardens convey a sense of order and mystery to downtown neighborhoods.*

▶ *Houses vary in their architectural details, from Georgian Colonial to Victorian, but their uniform placement on the perimeter makes each square cohesive.*

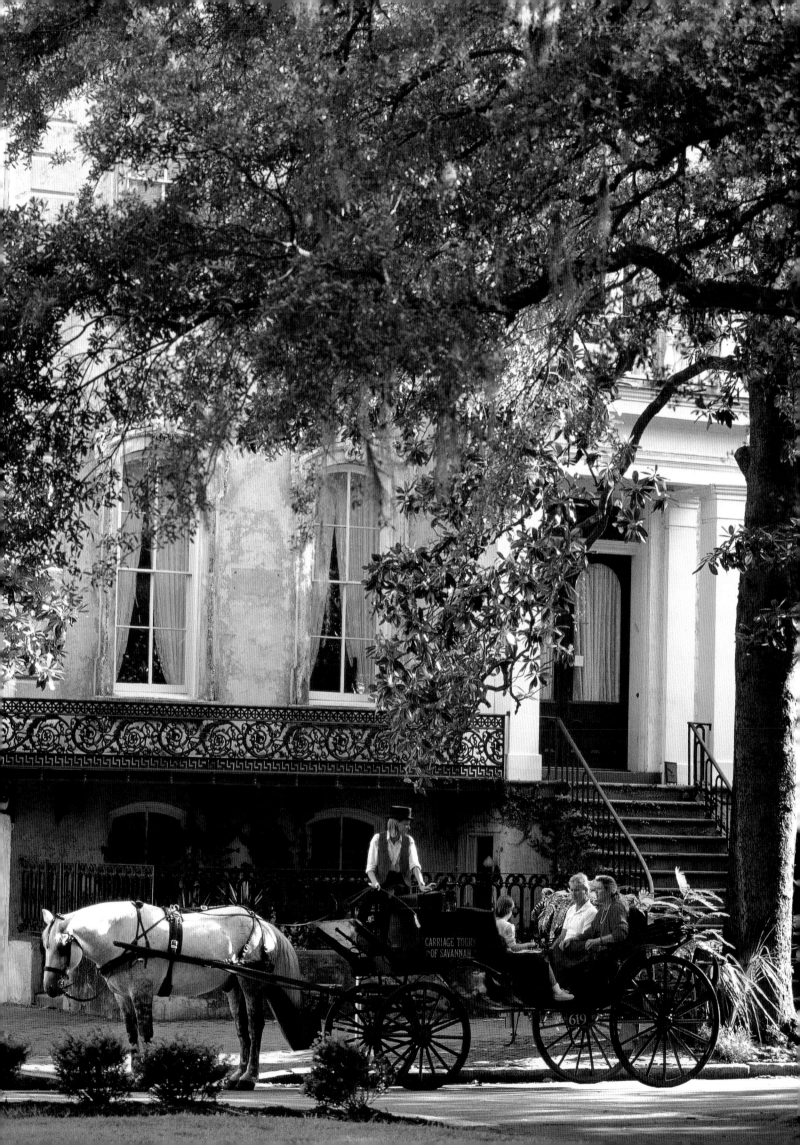

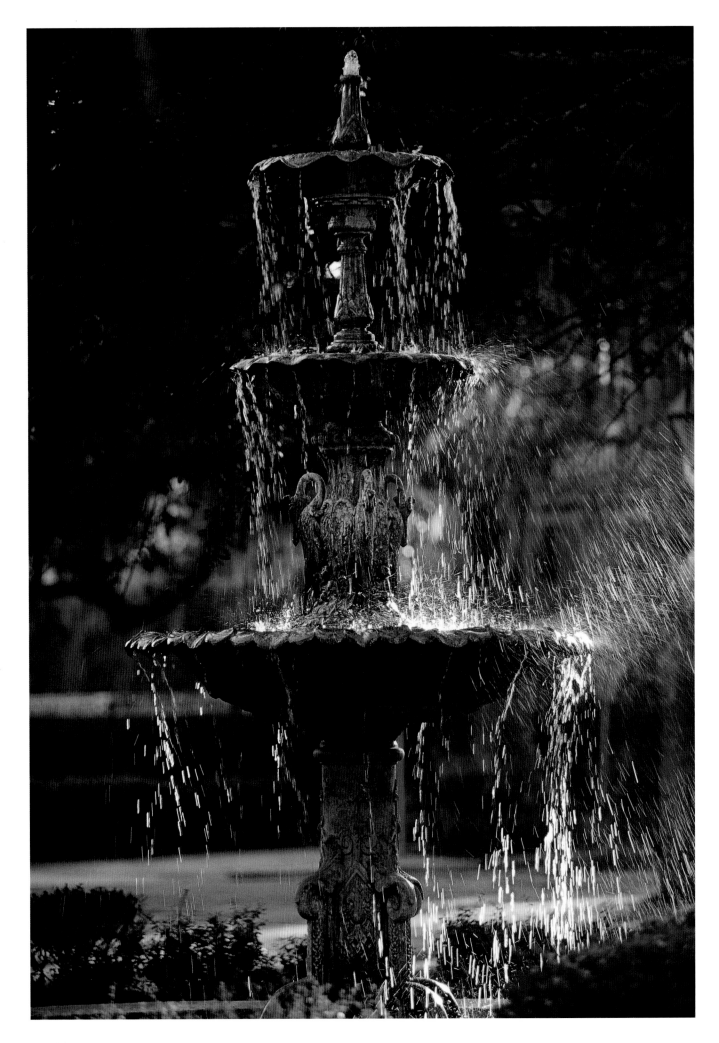

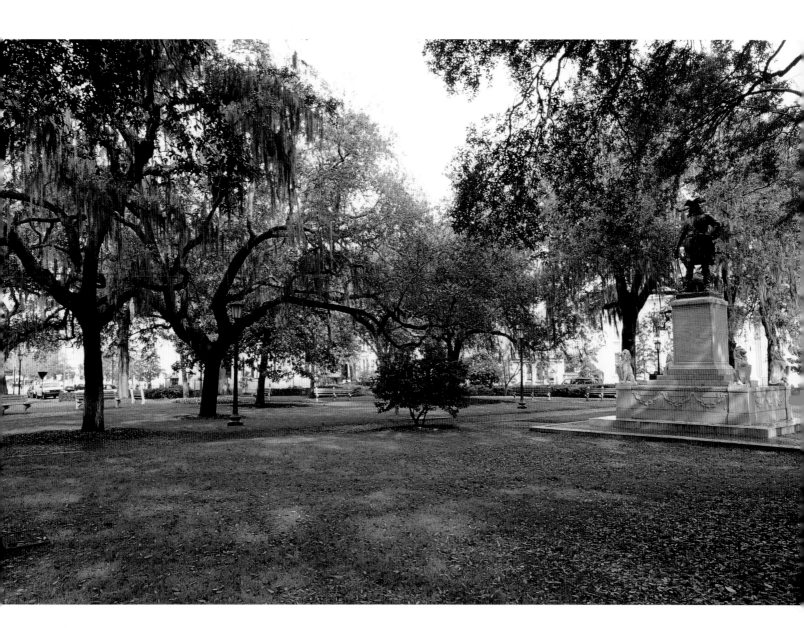

(from page 80) with American exports. At the same time, Savannah became the point of entry for Irish, Jewish, Greek, Swiss, and other immigrants; their descendants make the city an unusually diverse place today.

Savannah is described by its squares, which are bounded by linear one-way streets and broad parkways whose medians, in spring, are a cascading arbor of flowering azalea, overhanging live oak, and clusters of redbud and dogwood. Downtown is compact. Automobile traffic slows every few blocks to wind its way around the squares, small parks, really, which are landscaped with fountains, flowering hedges, and native trees filled with mockingbirds. There is no way to zoom around, and few people try. The squares themselves are the focal point of the houses on their perimeter: brick and stucco row houses with iron balconies, grand mansions with marble stairs, homes the color of "Savannah Grey," which takes its name from the old, locally produced brick. They're larger than conventional red brick, and depending on the time of day and the time of year, they take on a pink or tan glow. They soothe as ruins do, providing a rest to eyes astounded by purple wisteria, pink crepe myrtle, and red camellias. It was here that the American Regency style first took hold, when homes became urban villas. The Owens-Thomas House, the William Scarbrough

✥

◄ *Savannah is more visually dense than Charleston, so its open space and fountains provide a visual perspective and relief.*

▲ *Monuments in parks celebrate Revolutionary heroes like Pulaski, Greene, and Jasper; founder James Oglethorpe; and Yamacraw Chief Tomochichi.*

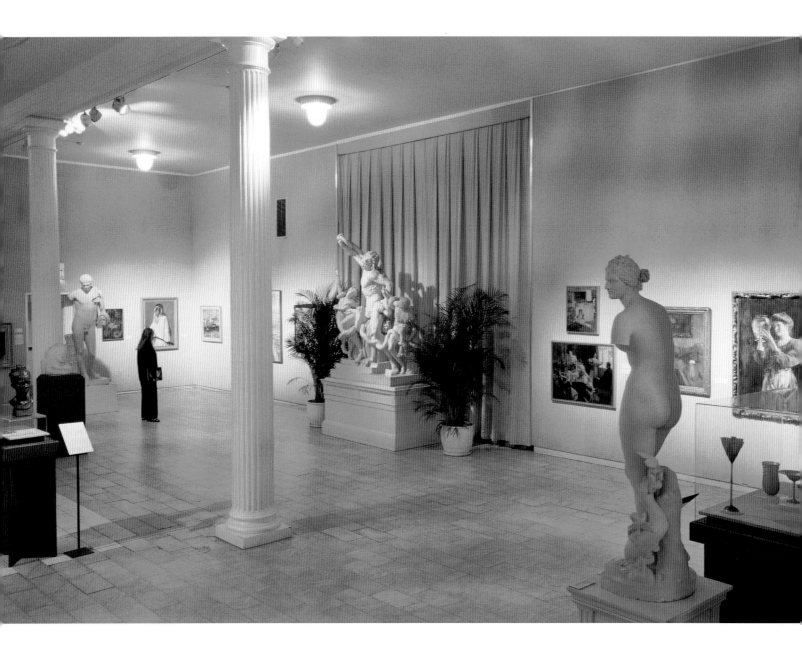

House (home to the Ships of the Sea Museum), and the Telfair Museum are the city's best examples.

A thriving world of antiques stores, luxury inns, and boutiques has grown up in and around the squares. And as Savannah has prospered, so have city initiatives to improve older commercial areas. City Market has artists' studios and many places to eat outdoors; River Street is a stretch of popular, perhaps noisier bars, shops, and restaurants located on the lower levels of the old cotton warehouses and cotton factor's offices; dozens of huge Victorian houses by Forsyth Park were restored with loans and sweat equity, many by African-American families; and the old downtown area around Broughton Street has been brought to life with renovated grand hotels and movie theaters.

But the biggest impact on city life has been the presence of the Savannah College of Art and Design, which since its founding some twenty years ago has adapted about forty buildings and turned them into bookstores, galleries, performing art spaces, classrooms, and housing for students. As a result, the city is bustling and places like old filling stations now sell organic bread. The former Greyhound station is a fine restaurant. There is also a renewed

▲ *The Telfair Museum, located in the mansion of a prominent old family, specializes in American paintings and decorative arts and hosts intimate musical events.*

▶ *Ongoing museum expansion has involved scores of downtown residents and world-class architects seeking a design to blend the new with the old.*

Savannah. 14th July
1886.

My dear Daisy
 Ever since the
receipt of your letter announcing
your engagement I have been
intending to write you. You know
what place is paved with good
intentions and I really believe
 to it, anyhow

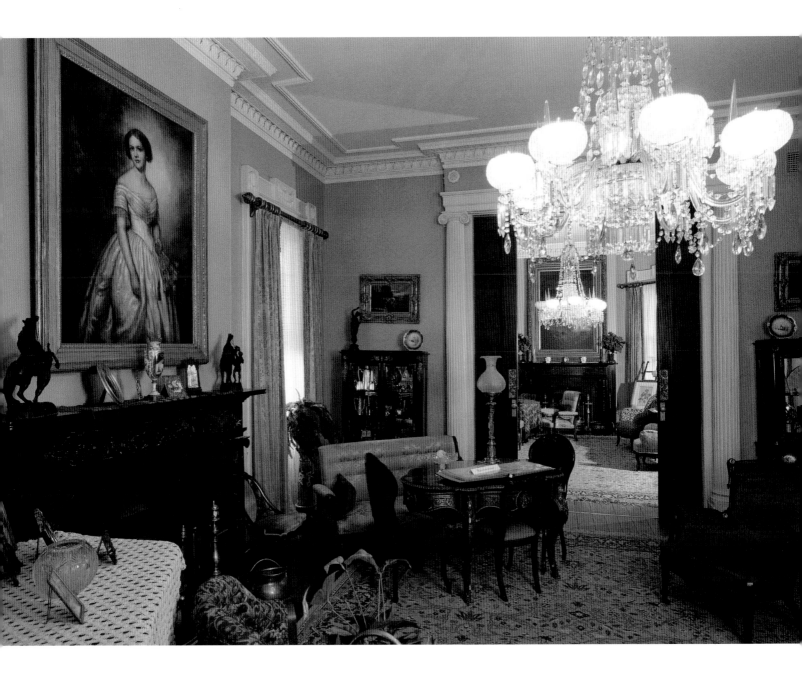

appreciation for art of all kinds, including the folk-art sculptures of Ulysses Davis, a Savannah barber whose collection is on view at the Beach Institute, a school established in the 1860s to teach the newly freed slaves.

This is not to say that Savannah has lost its unpolished side. That is in full view at Tybee, the island beach about twenty-five minutes east of Savannah where the Lowcountry tradition of bare feet and crab docks and houses set upon stilts prevails. Like other Sea Islands, Tybee was linked to the mainland only in the 1920s when its main attraction was a wood frame pavilion on the beach. Here, teenagers cruised with cherry Cokes, and their parents came to dance. Today the road from Savannah heads across acres of salt marsh, past biking trails, boat landings, and down-home restaurants like the Breakfast Club and the Crab Shack. You can pull off the road to rent and launch a kayak to explore the protected creeks, or you can visit Fort Pulaski, which came to prominence during the Civil War only to be rendered obsolete when cannons punctured its brick walls. Before the Civil War, Robert E. Lee was posted here.

◄ *A rich inventory of authentic objects, from items on a desk to neighborhoods of historic houses, reinforces the Lowcountry's unique sense of place.*

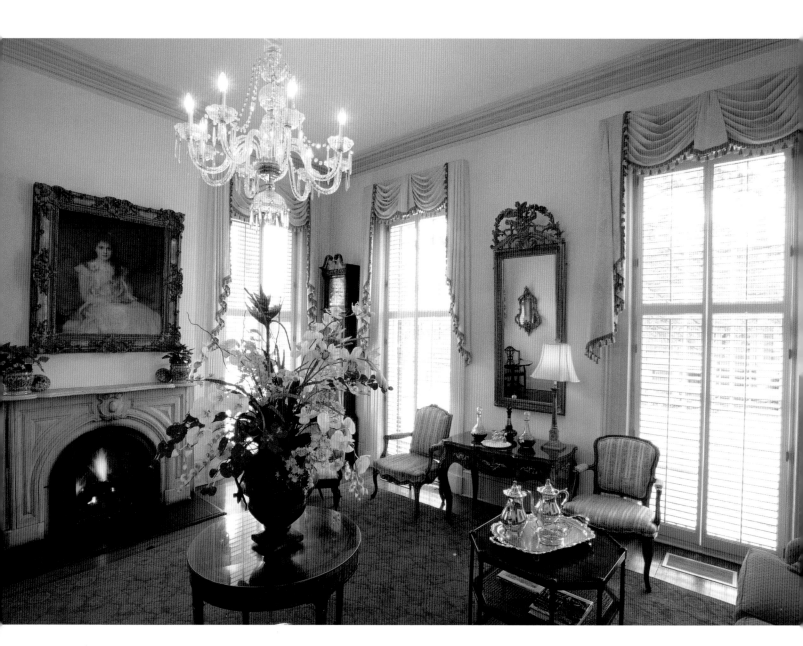

Tybee is not far from the city, and yet it is filled with bird life, including peregrine falcons who have been known to make their way back to perch in Johnson Square for old time's sake. Naturally, the ocean and the rivers are filled with fish and shellfish you can catch and eat, as well as dolphin who, if you are in a kayak, a john-boat, or aboard a fishing charter, may swim up close and stay with you. For as urban as Savannah is—and for many urban planners it is the signal precursor to the modern American city—there are still wild and verdant places close by.

The Savannah Wildlife Refuge is one. Located up Highway 17 toward the South Carolina border, this preserve is spread across more than twenty-five thousand acres of former rice fields, and includes freshwater marsh, river-bottom hardwood forests, and swampland. It is a resting spot for thousands of migrating birds on the Atlantic flyway and home to eagles, hawks, deer, alligators, and fox. The Laurel Hill Road and forty miles of hiking trails provide access. Another is Pinckney Island National Wildlife Refuge, a smaller complex (4,053 acres) composed of hammocks, tidal marsh, and creeks. It sits in Skull Creek at the foot of the bridge to Hilton Head Island, and yet once you're in

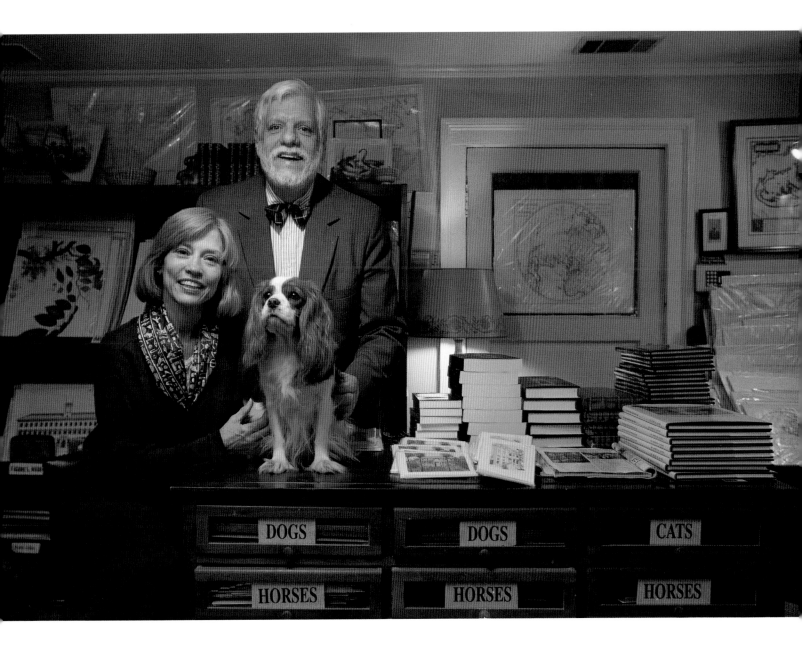

DOGS · DOGS · CATS

HORSES · HORSES · HORSES

about a quarter mile on the trail you could be back in time two hundred years, when it belonged to the Pinckney family. This is the Lowcountry's "before" picture.

Once across the bridge, on Hilton Head Island, there is not a great presence of the long ago. There are Native American shell middens and shell rings (piles of oyster shells used for cultural and domestic purposes) within Sea Pines Plantation, and there is the expansive Atlantic beach, bare as it ever was, but the island is a new creation, highly planned, with trimmed golf fairways lapping at the fresh blacktop and hundreds of places to stay and eat. It is a family resort with all the amenities, including marinas, tennis courts, and shopping, but it is driven by golf: there are some one hundred and forty courses between Savannah and the southern end of Hilton Head.

When the bridge came to Hilton Head in the late 1950s, the island was for the most part divided into large sections owned by Northerners for hunting or by Southerners for timber rights; and smaller sections owned by African-Americans whose families had worked the land as slaves. Mitchelville, one of the first rural, self-sustaining African-American communities in *(to page 99)*

▲ *John and Virginia Duncan indulge their passion for fine antique printed material of all kinds in their jewel box of a store.*

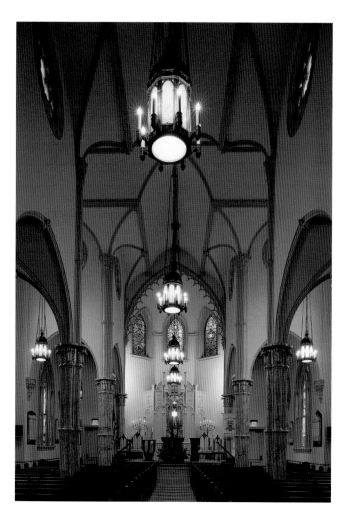

❧

▲ *Temple Mickve Israel, noted for its*
rare Gothic design, serves a congregation
established in the late eighteenth century and
today houses the country's oldest Torah.
▶ *Roman Catholics who attend the Cathedral*
of St. John the Baptist worship in a setting
more reminiscent of seventeenth-century France
than twenty-first-century Savannah.

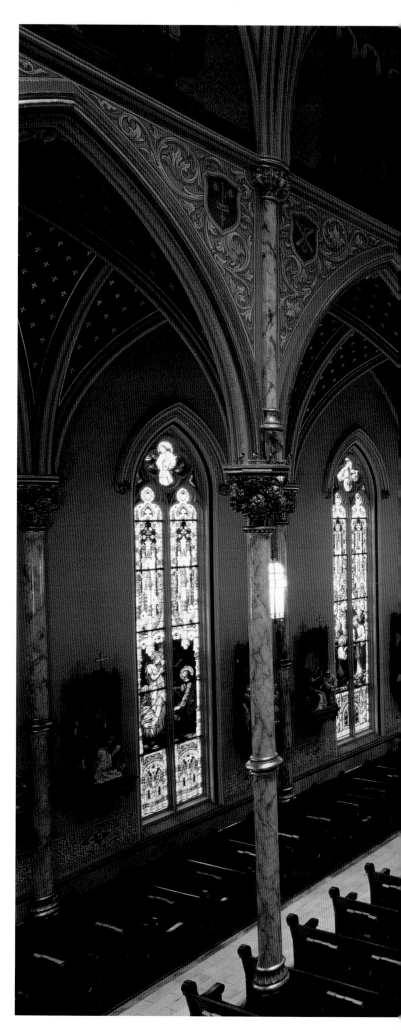

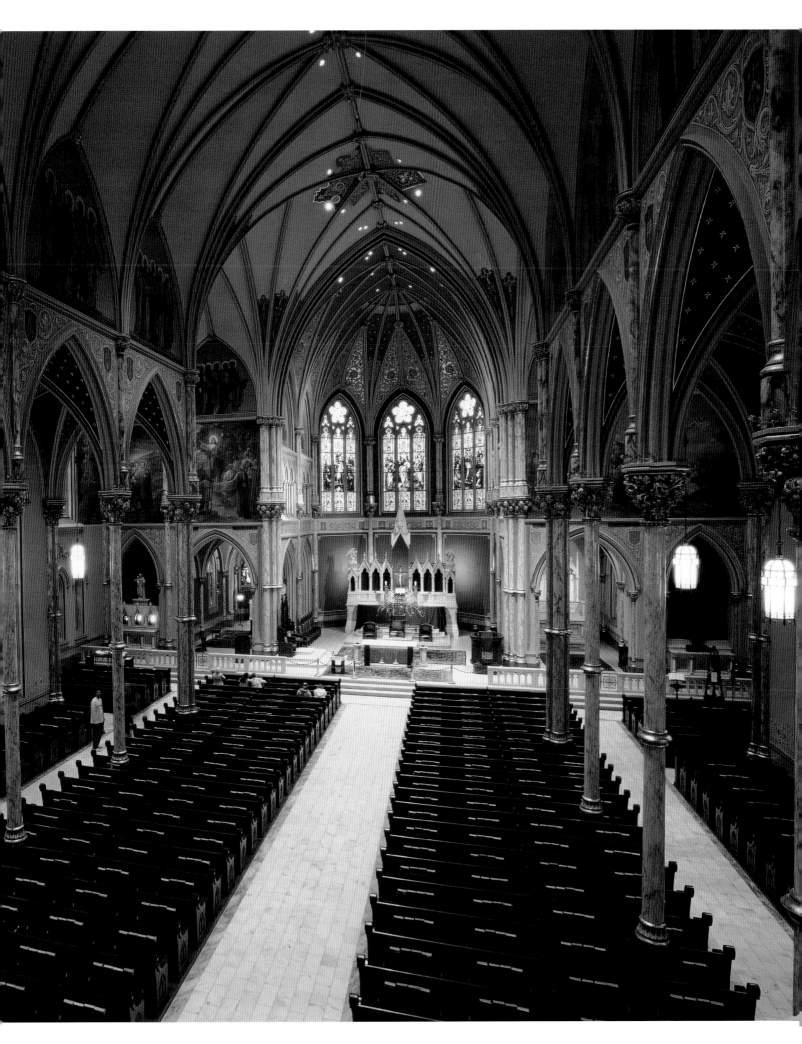

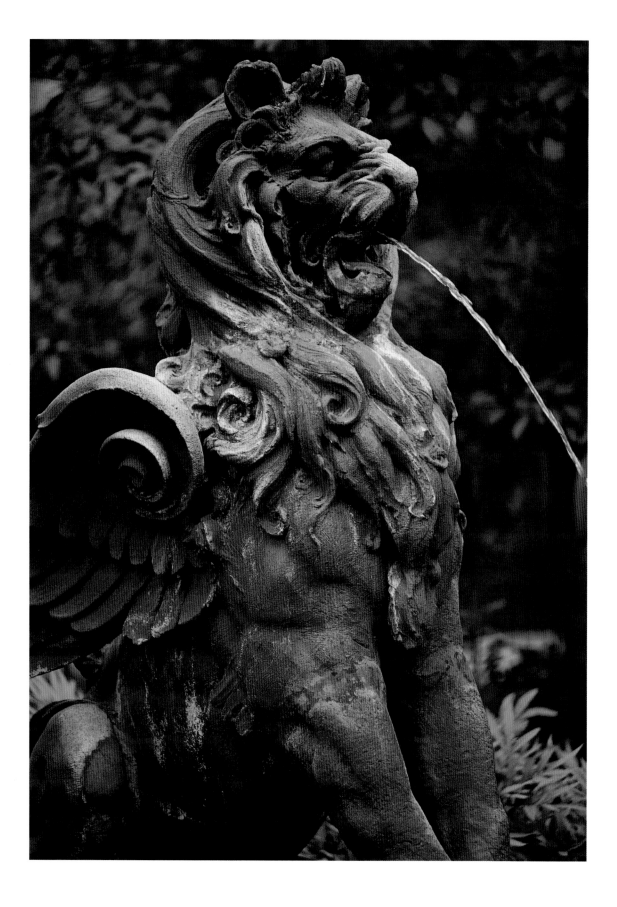

🌿

▲ *The griffin who stands watch at the Cotton Exchange is a mythical beast,*
strong as a lion and endowed with an eagle's eye.
▶ *The Cotton Exchange (c. 1886) flourished when Savannah was the*
export capital for cotton, naval stores, and lumber.

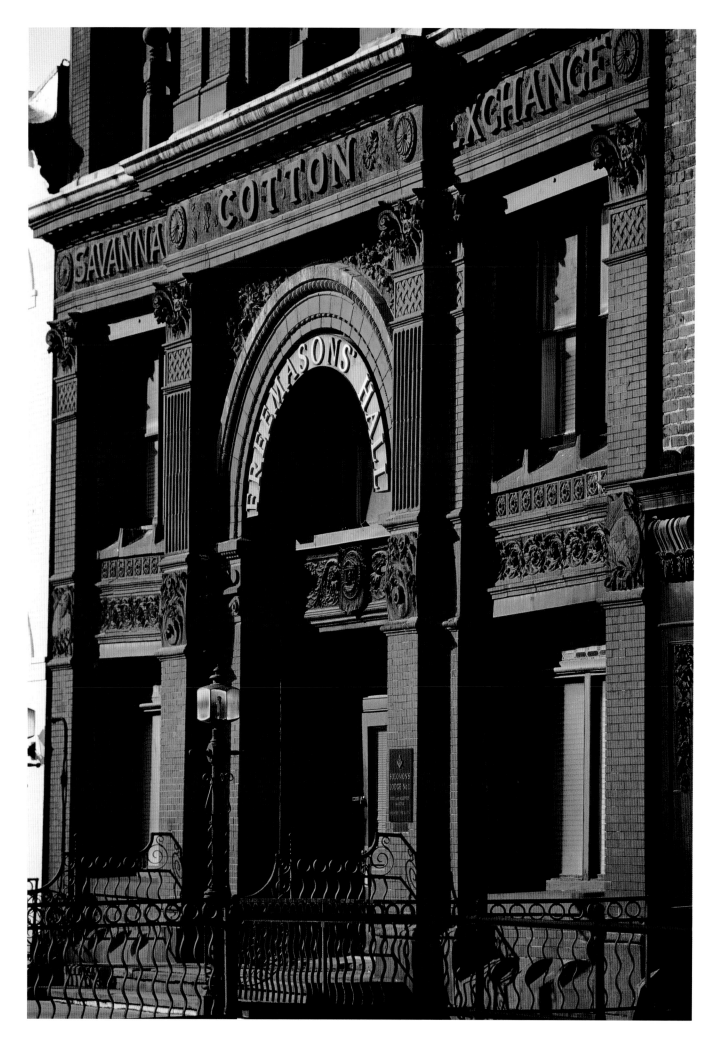

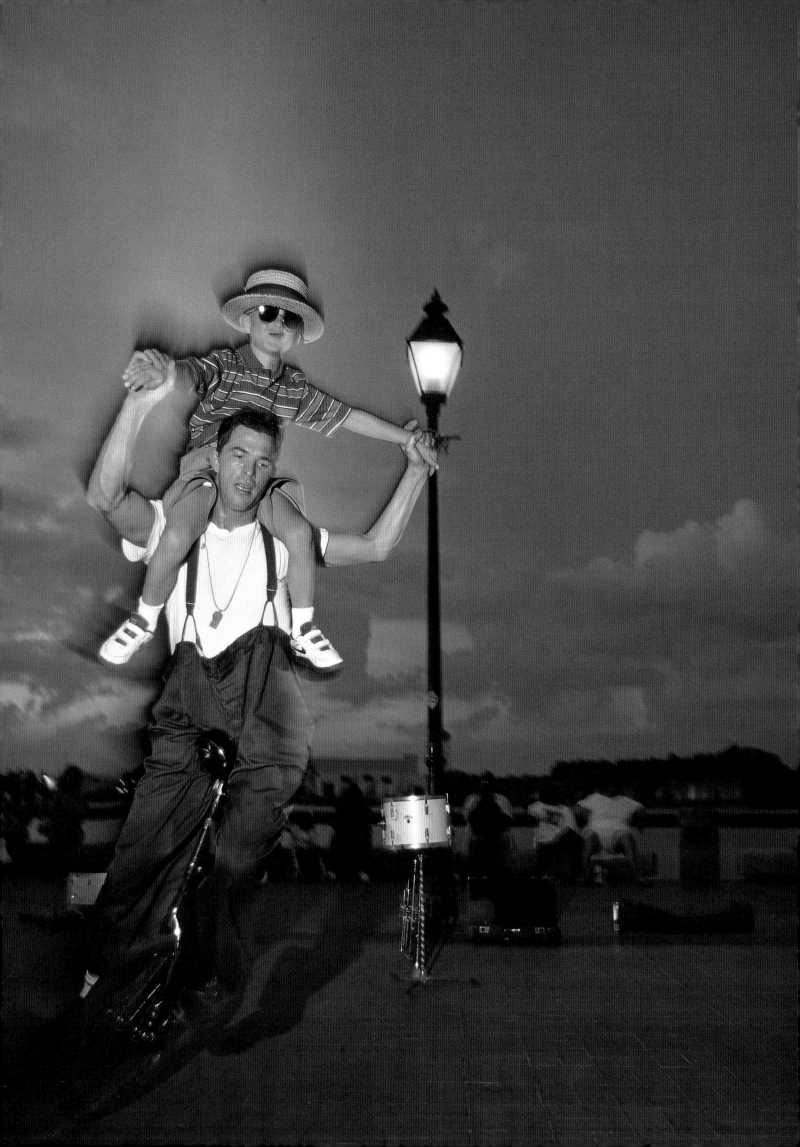

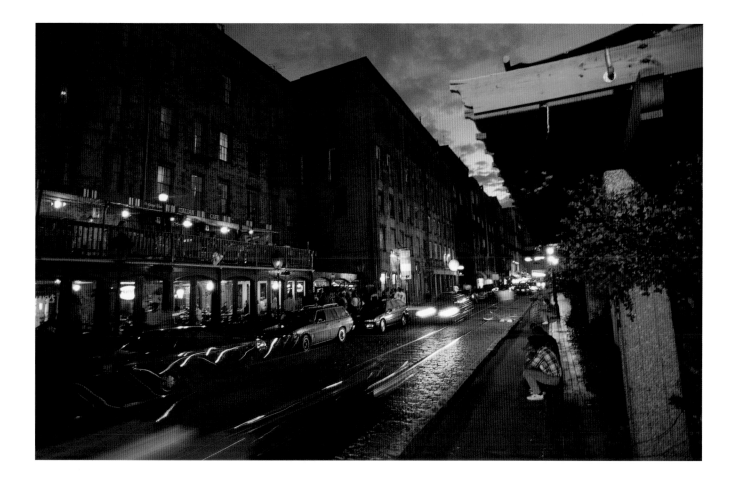

(from page 93) the country, is on Hilton Head, and you can get a good sense of it in photographs at the Museum of Hilton Head Island. Many of these families have remained, and some have developed their own land. The large resorts have become so successful that they are brands. It is hard to imagine that there wasn't always a Sea Pines or Palmetto Dunes or Hilton Head Plantation. Up around them has grown a strip-mall culture that is benign—few obvious logos or lights—yet dense with traffic at times and approaching the sense that it could be anywhere else. Nonetheless, the island, riven by Broad Creek, and flanked by Calibogue Sound and Port Royal Sound, and fronting the Atlantic, is in a beautiful spot. It's no wonder the Union generals chose it to be the fleet coaling station and headquarters of occupation for the southern coast. For all its tourism success, Hilton Head bears the civic pride of a small town, with an excellent daily newspaper, public beaches, and miles of bike paths.

Across Calibogue Sound is Daufuskie Island. It has a burgeoning resort section, but is accessible only by ferry and will remain so. Thus its sense of isolation is intact, as are its rutted sandy roads, church, schoolhouse, and cemeteries. A plantation and farming community, it lost its economy when the oyster industry died due to water pollution in 1959. There are daily tours, often highlighted by a stuffed crab supper, a Daufuskie specialty. Although Daufuskie is no longer the vibrant place it used to be, it will never be dominated by those who can afford to. Not having a bridge helps, of course, but in fact the whole idea of domination in this area is an illusion. People have been trying for hundreds of years. Savannah has an unashamed wild side, after all—and don't ever find yourself on the Broad River in a summer rainstorm.

◆

◀ *Entertainers perform on River Street, where waterfront shops and restaurants flourish.*
▲ *Iron balconies and bridges lend an Old World air to the long row of nineteenth-century brick warehouses where cotton factors brokered the crop.*

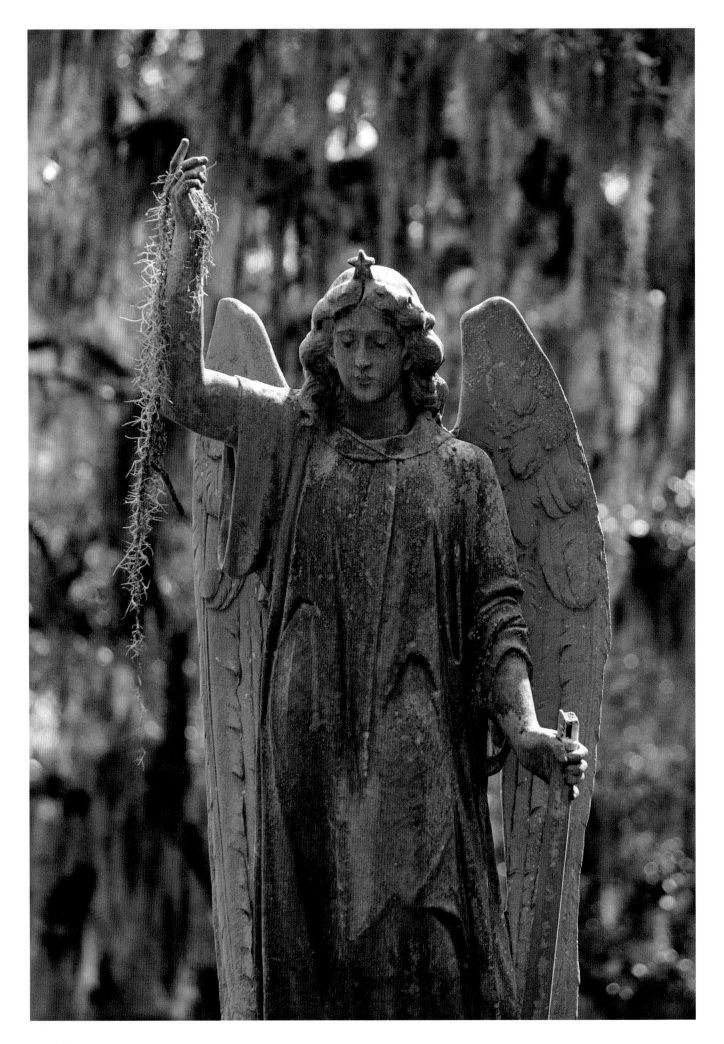

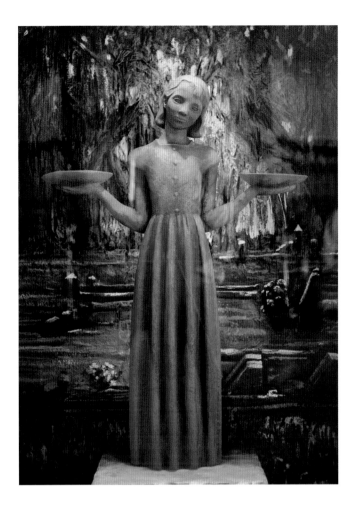

◀◀ *Lushly landscaped cemeteries honor the dead, including Colonial Park, which was a burial ground for colonists, and Laurel Grove-South, where slaves and free persons of color were buried.*

◀ *The original Bird Girl statue at Bonaventure Cemetery became an icon in the best-seller,* Midnight in the Garden of Good and Evil *and was removed for safekeeping.*

▼ *For a city that relies deeply on an ancestral past for its identity, the elaborate, formal statuary of its cemeteries keeps the connection open.*

▶ *Wormsloe is celebrated for its live oak avenue, but it was mulberry trees, planted by the first colonists for silkworm cultivation, that led to its early prominence.*

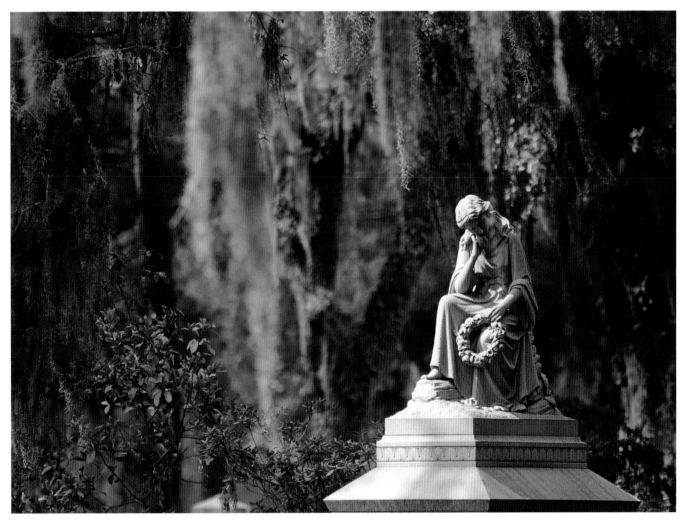

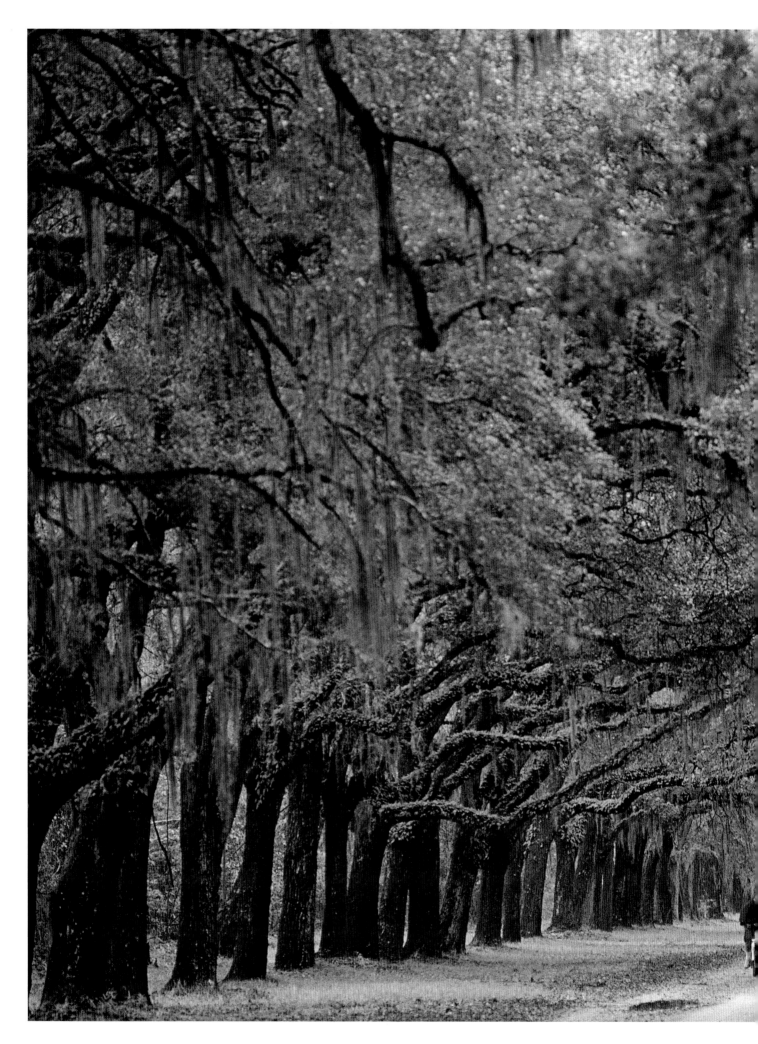

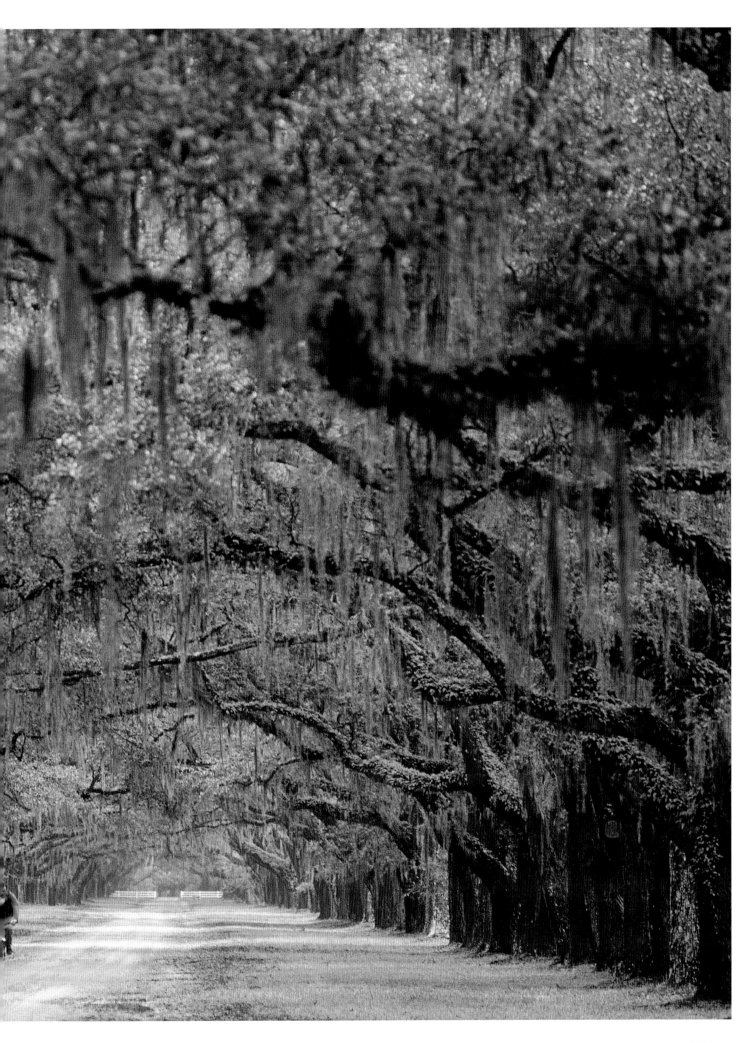

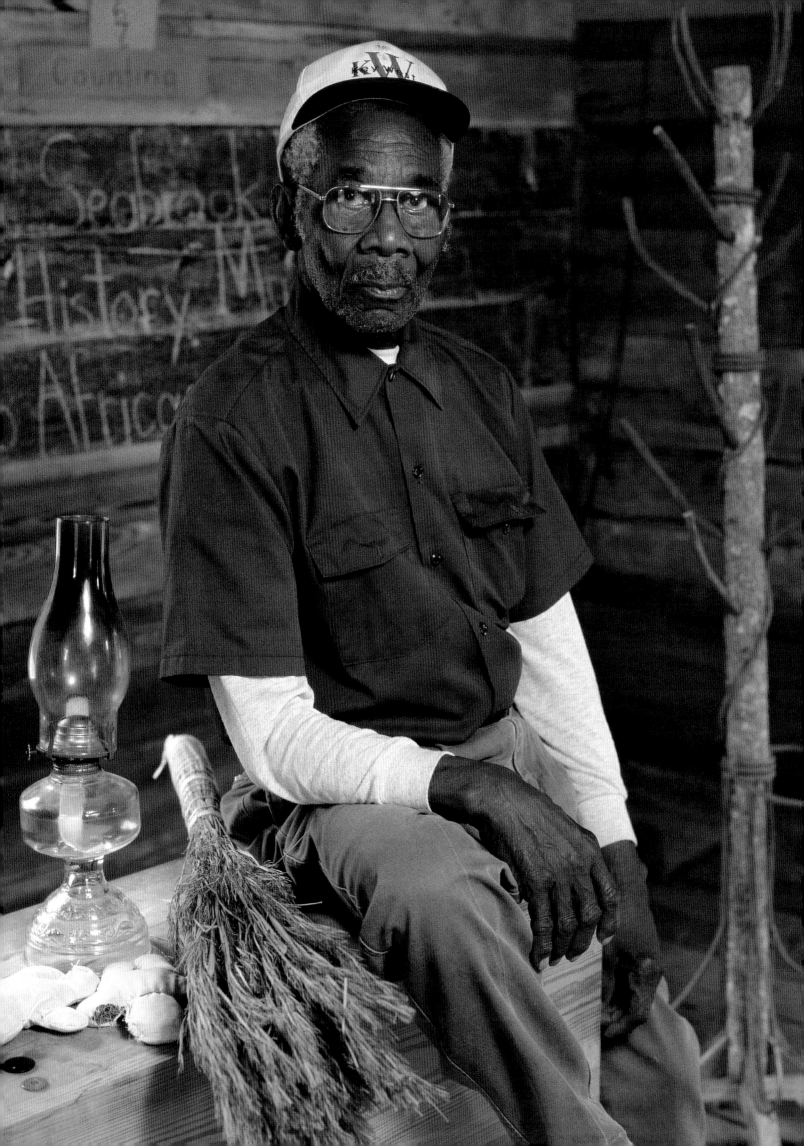

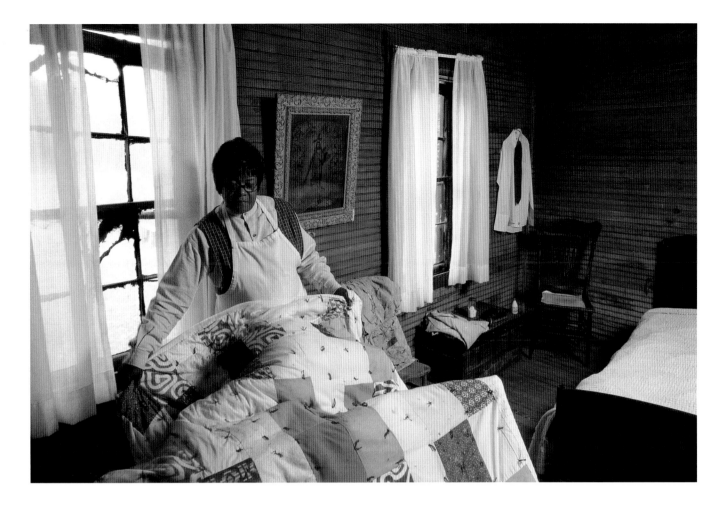

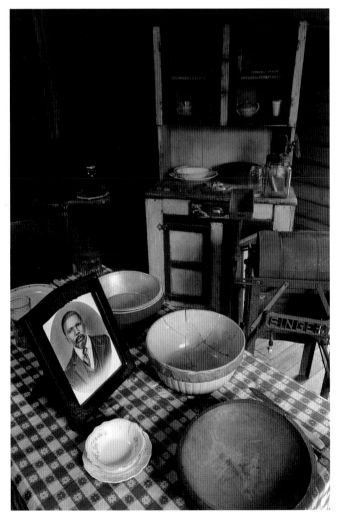

◄ ◄ *John Stevens with his handicrafts in a school he once attended and helped restore when it was moved to Seabrook Village near Midway, Georgia.*
▲ *Florence Roberts is a docent in her own grandfather's house, now part of the restored village.*
◄ *Simple crockery, furnishings, and utensils portray domestic life in the country.*

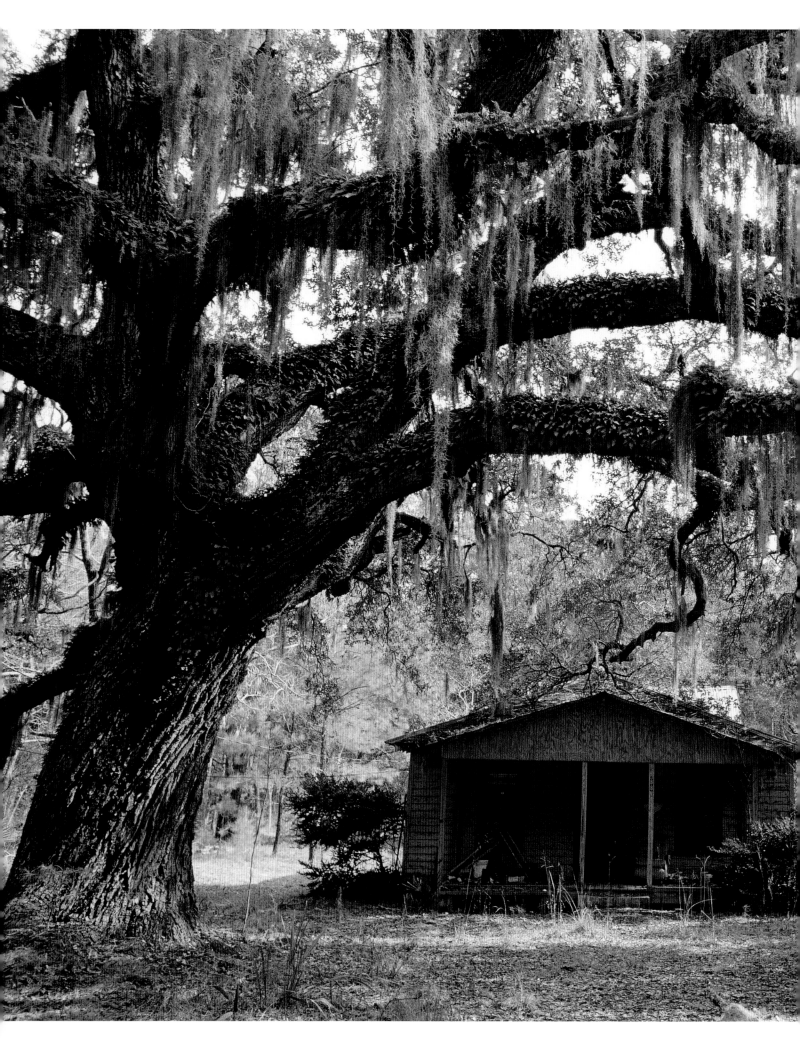

❧

◄ The undertaker's cabin on Daufuskie Island,
a typical Sea Island dwelling whose porch is
shaded by a majestic live oak.

▲ The sand roads of Daufuskie, Edisto,
and St. Helena are dotted with hand-built
houses that wear out and wear away.

► The rippled sand at low tide reveals a
broad stretch of beach on Hilton Head Island,
home to planters, Union generals, generations
of native islanders, and retirees.

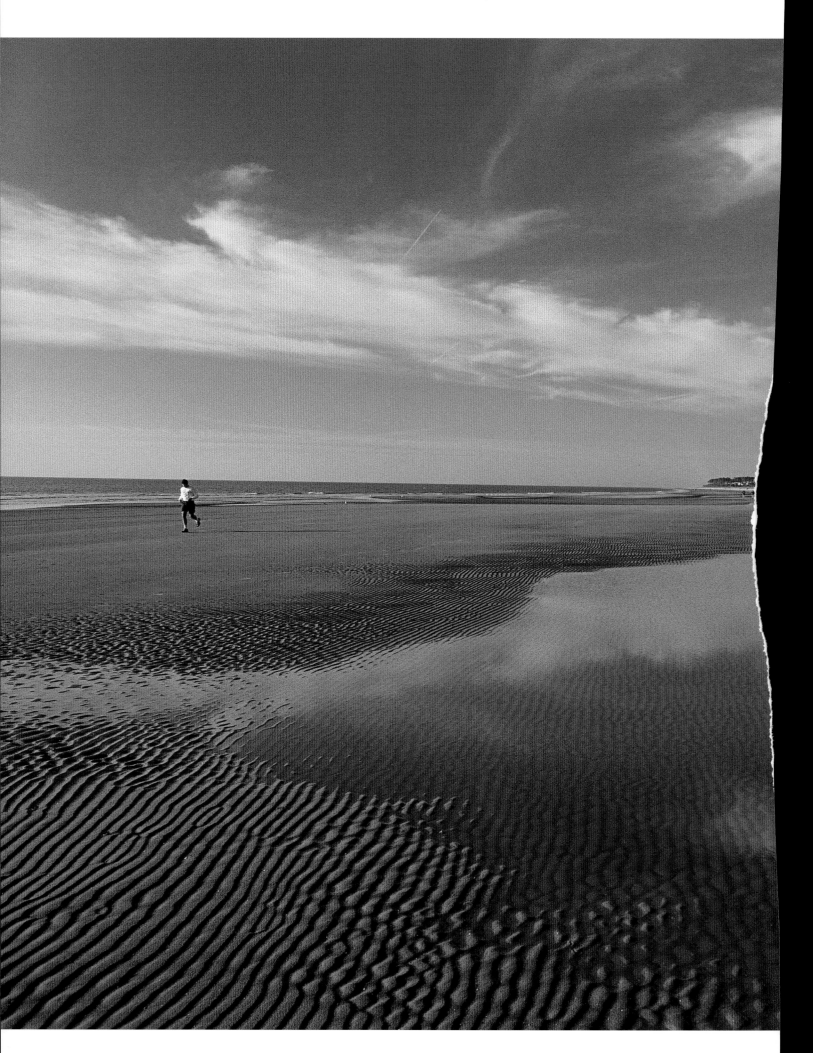

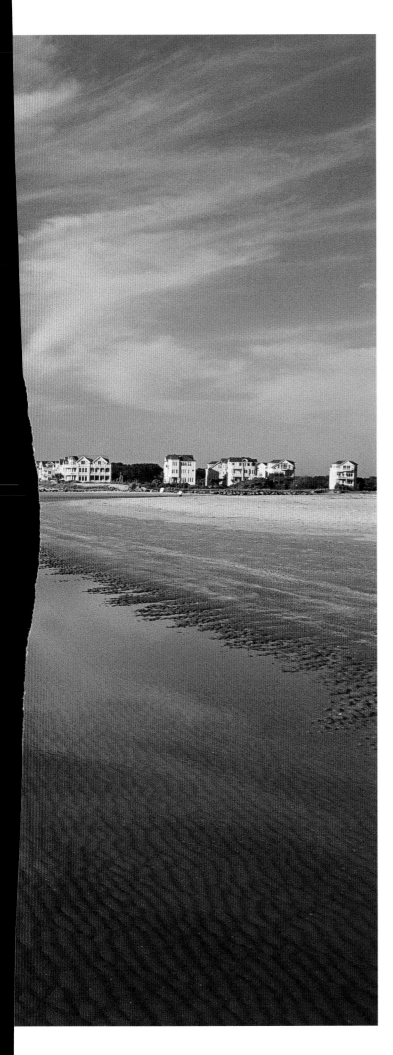

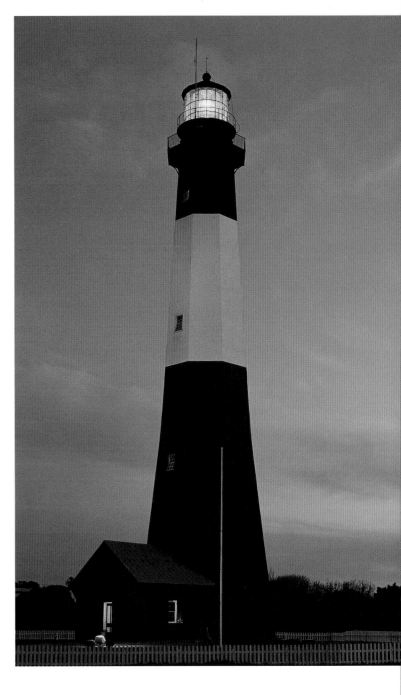

☙

▲ *Tybee Island Lighthouse, located where the river meets the ocean, is Georgia's oldest and tallest lighthouse.*
▶ *A pelican bank in Calibogue Sound off Hilton Head resembles hundreds of islands that dot Lowcountry waters, many so small they're nearly submerged at high tide.*
▶▶ *The ACE Basin—the Ashepoo, Combahee, and Edisto Rivers and their adjacent environments— describes an estuarine sanctuary of some 350,000 acres that has nourished the plants, animals, and sensibility of the Lowcountry.*

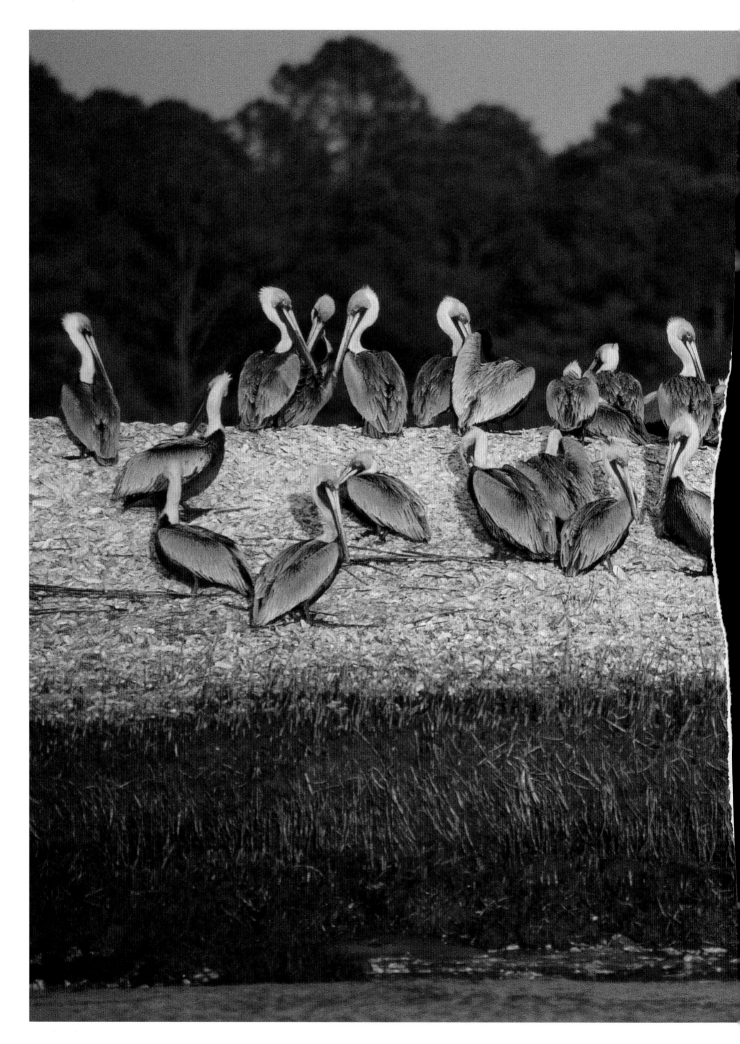

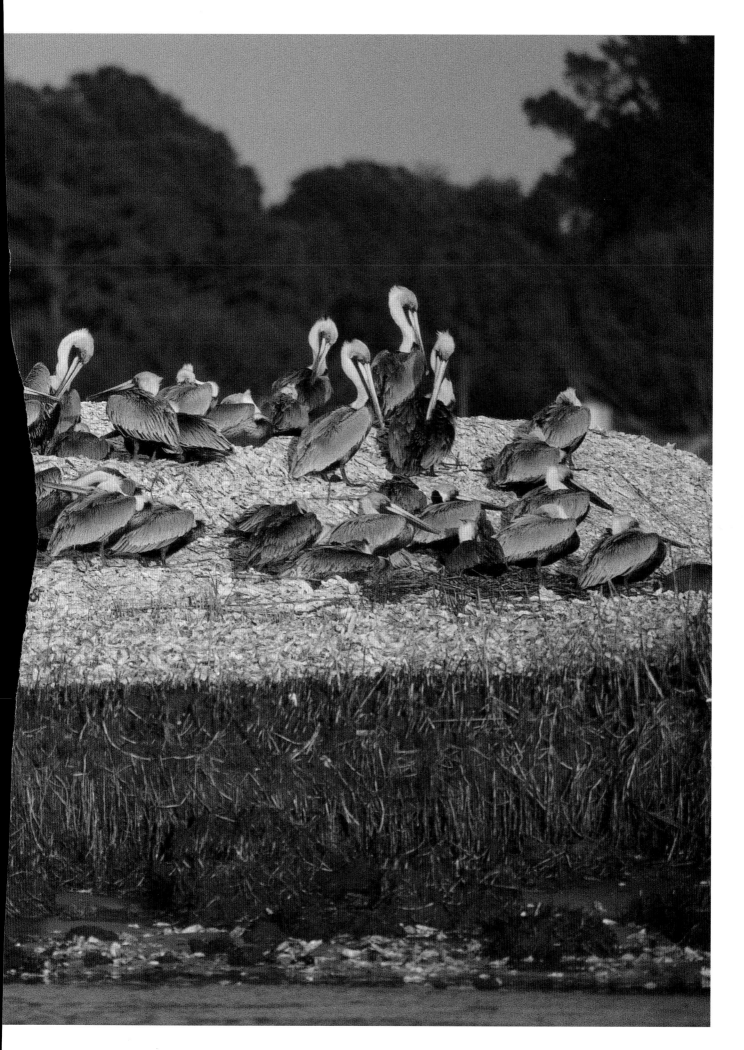

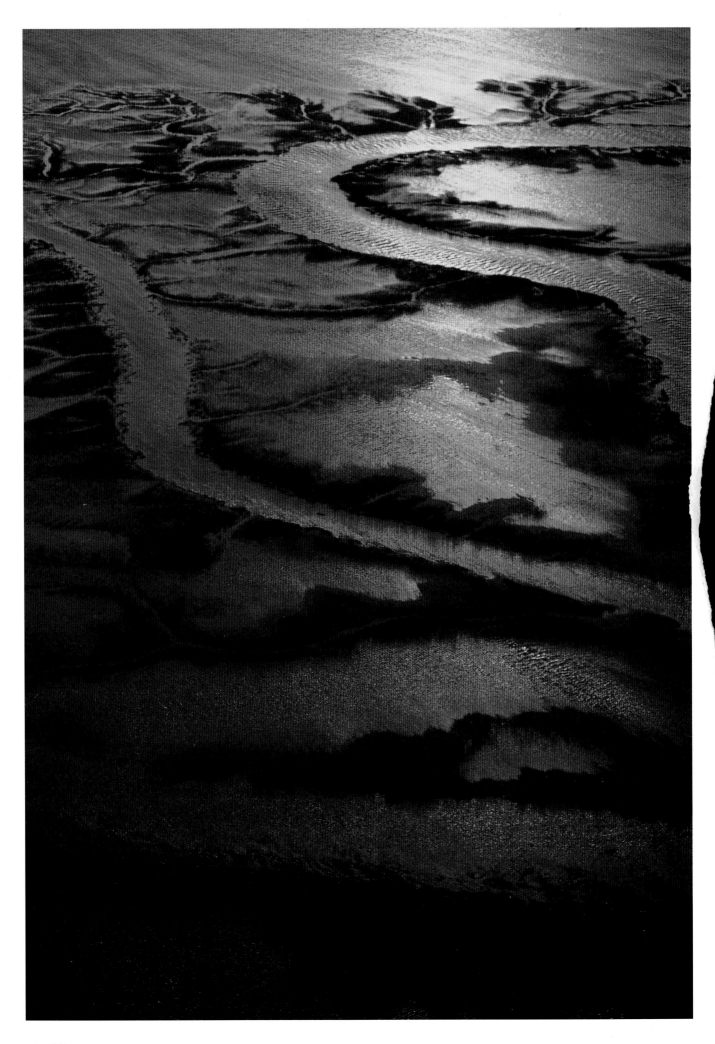